the

JOY

OF

iPhotography

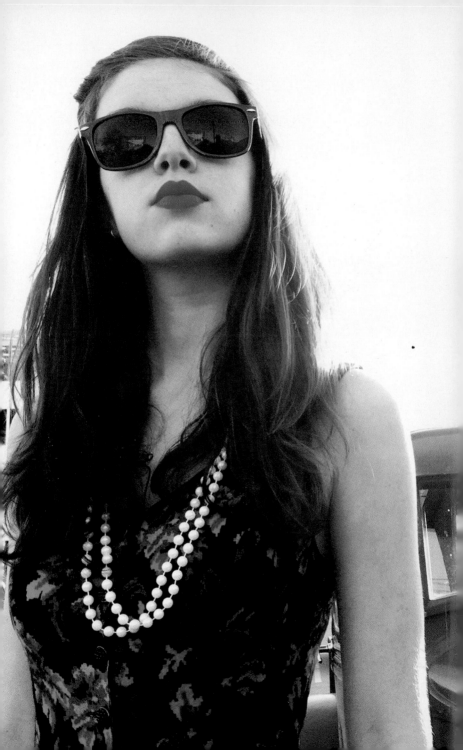

the JOY

OF

iPhotography

take
**AWESOME
PHOTOS**
with your
PHONE

Jack Hollingsworth

ilex

An Hachette UK Company
www.hachette.co.uk

First published in the United Kingdom
in 2016 by Ilex Press, a division of
Octopus Publishing Group Ltd
Carmelite House
50 Victoria Embankment
London EC4Y 0DZ
www.octopusbooks.co.uk

Distributed in the US by
Hachette Book Group
1290 Avenue of the Americas
4th and 5th Floors
New York, NY 10020

Distributed in Canada by
Canadian Manda Group
664 Annette St.
Toronto, Ontario, Canada M6S 2C8

Publisher: Adam Juniper
Managing Specialist Editor: Frank Gallaugher
Senior Project Editor: Natalia Price-Cabrera
Editors: Rachel Silverlight & Francesca Leung
Art Director: Julie Weir
Designers: Anders Hanson & Ginny Zeal
Assistant Production Manager: Lucy Carter

ISBN 978-1-78157-356-3

A CIP catalogue record for this book
is available from the British Library.

Printed and bound in China

10 9 8 7 6 5 4 3 2 1

contents

**This book is about mobile photography:
How to use your iPhone to capture life's precious
and fleeting moments and memories...
anytime, anyplace, anywhere.**

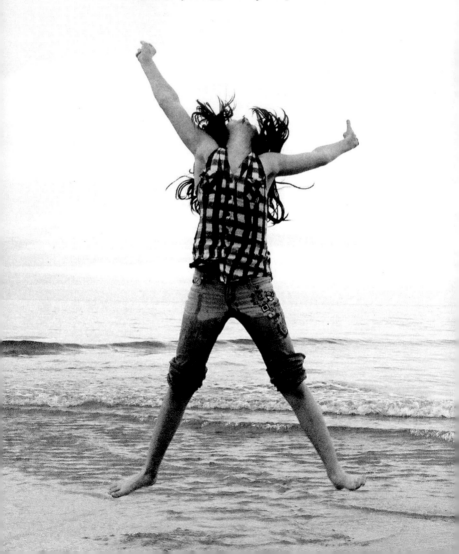

I have been a photographer for a long time, so the approach I'm taking here is photographic in nature. Once you begin to understand, appreciate, and apply the fundamentals of photography to your mobile work, you should start to see significant improvement in your photographs.

While we will certainly cover some of these fundamentals, this is not a book about apps or gear, or editing. It's about getting you to think of your iPhone less like a device and more like a camera, hence the title *iPhotography*. This is real photography, and your iPhone is a real camera. It's okay to take it seriously... and have fun...and be creative!

My goal here is simple: to inspire you and kickstart you in your own journey of making the best photographs of your life, with your iPhone.

All the photographs in this book were shot and processed on iPhones. In just five short years, I have shot more iPhone images than I did in a previous decade of DSLR shooting. I have never been more excited about photography that I am today. iPhone photography is wonderfully habit-forming.

This experience can be yours too. Please join me in this pilgrimage. Skim through the content. See what interests you. Read it, and then vigorously apply the ideas that speak to you.

If you're interested in knowing more about apps and websites that I love, communities I engage with, products I recommend, and education resources to get you going, see the Resources section at the back of the book. I promise there are some real gems in there that you'll be glad to know about.

1

CONSUMER
PHOTOGRAPHY

"PEOPLE, THERE'S NO SUCH THING AS THE BEST CAMERA BRAND, BUT YES THERE WILL ALWAYS BE THE BEST CAMERA AT ANY GIVEN TIME. TECHNOLOGY WILL CHANGE, BUT NOT ART."

Ashraf Saharudin

Smartphones have democratized photography all over the world, for every man, woman, and child. It's a true cultural Zeitgeist.

Never before, in the history of photography, has image making been so remarkably popular, celebrated, and loved. Smartphones have made photography the new lingua franca of planet Earth.

The balance of power has shifted from pros to consumers. These consumers are changing the conversation about photography, and changing where that conversation takes place—now in the palms of our hands.

As a culture voracious for photographic stimulus, we are no longer solely fixated on technical image quality. In the new smartphone economy, content trumps craft. What a picture says says is more important than how it was created.

Thanks to smartphone technology, led by Apple, this broader, more inclusive conversation includes creativity, affordability, accessibility, entertainment, and communication.

Photography is no longer defined as a physical product—it is an emotional experience. For so many of us around the globe, mobile photography is an integral part of our lives. It is a basic mode of communication.

iPHOTOGRAPHY BY THE NUMBERS

As I sit here looking at the numbers, I'm flabbergasted by the number of photos we take, day in and day out. The overwhelming majority of them, we take with our smartphones.

Since the camera was officially invented in the 1840s, it is estimated that we have taken approximately 4 billion analog photos. We now take about the same number of photos every single day. Smartphone photography isn't an evolution...it's a full-blown revolution with global reach.

How about this? 10% of all photos ever taken were taken in the last 12 months. Or, this bombshell: Approximately 140 billion photos have been uploaded to Facebook. That's 10,000 times the number of photos in the Library of Congress!

As of today, there are 7.4 billion people. According to some industry analysts, approximately half of these people own a smartphone. Let's conservatively assume that every smartphone owner takes one photo a day. That comes out to 1.3 trillion photos a year. And we are only talking about smartphone photos here (likely around 90% of all photos taken). Let's round this number down to 1 trillion photos a year to be conservative.

What does a trillion look like? If each photo were a 4x6 print, and you lined them all up end-to-end, they would stretch out over 200 million miles, or 1.1 round trips from Earth to the sun.

A PHOTOGRAPHIC APPROACH TO iPHONE PHOTOGRAPHY

"WHEN WORDS BECOME UNCLEAR, I SHALL FOCUS WITH PHOTOGRAPHS. WHEN IMAGES BECOME INADEQUATE, I SHALL BE CONTENT WITH SILENCE."

Ansel Adams

I've had a camera in my hands since the early 70's and I'm proud to say that I've made both a life and a living in photography. It's in my blood. Thanks to my beloved iPhone camera, I'm more deeply connected to my photography now than at any point I can remember in my four-decade experience.

In that respect, the iPhone camera is a magical tool. It empowers anyone to create the best photographs of their life. It is ridiculously easy to understand, but it is also an art form that can take the better part of your life to really master.

My mobile mantra is "less phone, more camera," as in, think of that device in your hand as mostly camera. While so many seem to migrate from smartphones to big cameras, my journey was the reverse. I brought all my pro sensibilities and sensitivities with me, and what did I learn? It's still photography.

I'm a photographer at heart, and I will always have a photographic approach to my iPhone shooting. My approach is not the only way, but it's what works best for me, and I suspect it will resonate with you if you're reading this book.

CURATE YOUR
OWN WORK.
**Shoot many,
share few.**

**Let photo apps
refine your style,**
NOT DEFINE IT.

MAKE YOUR IPHONE PHOTOGRAPHY
**more intentional,
less casual.**

UNADULTERATED JOY

"ONE DOESN'T STOP SEEING. ONE DOESN'T STOP FRAMING. IT DOESN'T TURN ON AND TURN OFF. IT'S ON ALL THE TIME."

Annie Leibovitz

Most iPhone photographers have little to no training or experience in photography. None of that is important. What is important is learning to see, then figuring out how to capture what you see. There's no need to compare yourself with others who have been shooting longer than you. Just shoot.

I have always found joy in the labor of my photography. Always. If you're not having the time of your life shooting with your iPhone, reassess right away! Free from photographic dogma and doctrine, iPhotography offers a liberating sort of joy that truly awakens the artist within all of us.

LEARN TO TRUST YOUR OWN intuition, instincts, impulses.

Take a photo every day OF YOUR LIFE.

Invest a weekend OF LEARNING THE TECH PART OF THE IPHONE CAMERA.

Just shoot. And do it with joyfulness and elation. This rushing fuel of delight is all you need to get you going and kick start your journey in iPhone photography. You'll experience a rush as you turn your subject into the delight of a photograph, and unlike traditional cameras, there is little in the way of buttons, dials, knobs, and menus to spoil that fun.

Instead, each photo promises a double dose of delight: the moment of capture and then the opportunity to share. My heart still palpitates at the rush of another beautiful capture. The best news of all is that we have only just begun.

I do believe, with all my heart and soul, that the iPhone camera will go down in history as the most influential capture device ever manufactured in the history of photography. Joy of joys!

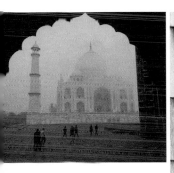

**Shoot the things
that you love
AVOID THE REST.**

**Invest a weekend
OF LEARNING THE TECHNICAL ASPECTS
OF THE IPHONE CAMERA.**

MY PERSONAL JOYS

Shooting with my iPhone camera has brought me joy on so many levels. In a way, it has changed everything about photography for me. The following are my top joys in iPhone photography so far.

THE JOY OF FOCUS When the iPhone camera is in my hands, I get to focus on the creative stuff that drew me to photography in the first place. Because the iPhone has limited tech, I never feel encumbered or disadvantaged. I see, I shoot, I share. Done!

THE JOY OF APPROACH I've always enjoyed the street cred that comes with being a working pro. But, with the iPhone, I'm just like everyone else. That gives me all kinds of access and approachability that I ordinarily would not have, which makes a big difference in the photos I can snag. Instead of standing out, I blend in.

THE JOY OF EDITING In the studio, I have always had staff retouchers that did all my Photoshop work. Now I can do it myself. And, I have hundreds of app options to get just the look and feel I want. I continue to enjoy capturing over editing, but as many of you reading this can attest, there is so much fun in "apping." And, best of all, you can do it almost anywhere you have a free minute.

THE JOY OF VIDEO I'm quite the video junkie. I find myself shooting as much mobile video these days as I do stills. The iPhone makes the whole process of filmmaking so intuitive, fun, and easy.

THE JOY OF BRANDING For perhaps the first time in marketing history, I and people like me can build a photo brand through mobile. We primarily have Instagram to thank for that. In no time at all, and without much formal training, any photographer can have and maintain a global audience through mobile.

THE JOY OF PRINT Printing my photography has never been so easy. And there have never been so many products to print onto. You can shoot a masterpiece today, and through over a dozen printing apps, have a product on your wall or desk tomorrow. Printing your photography completes the creative process and brings much-needed tactility to the joy of photography.

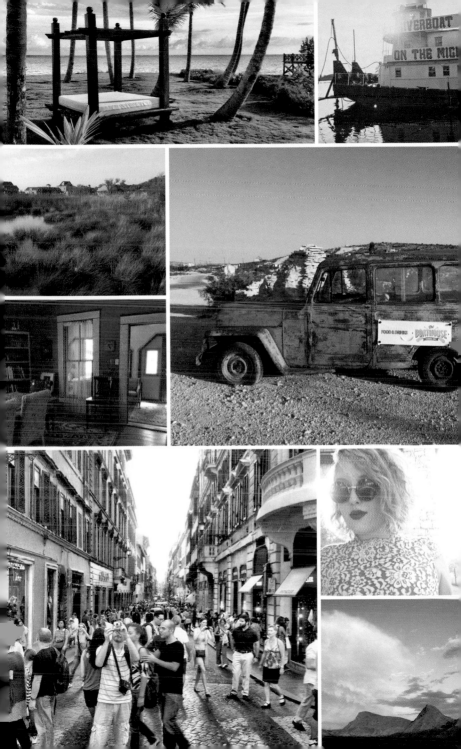

EENY MEENY MINY MO

"A GOOD PHOTOGRAPH IS ONE THAT COMMUNICATES A FACT, TOUCHES THE HEART AND LEAVES THE VIEWER A CHANGED PERSON FOR HAVING SEEN IT. IT IS, IN A WORD, EFFECTIVE."

Irving Penn

People are always going to talk about which camera is the best—DSLR or iPhone?

You already know what's good about the iPhone—it's always with you, it's (relatively) affordable, it'll do video, the files are of decent quality and, of course, apps expand the experience. Last but not least, it still has a pretty darn high "cool" factor.

The iPhone camera doesn't shoot all subjects, scenes, and situations equally well, though. It performs the best with static subjects, relatively close at hand, in bright natural light.

Rather than look at the technical limitations of the iPhone camera as a shooting liability, I like to look at it more like an opportunity to focus on creative aspects—the very reason I was attracted to photography in the first place. Returning to these roots is refreshing, liberating, and provides the perfect excuse to spread your wings and soar to new artistic heights.

The long and short of this choice between big camera or iPhone is really simple. Sometimes it will make sense to use a "real" camera. Other times, it will make sense to shoot with an iPhone. Since this is a book about iPhone photography, I'm going to do my very best to show you tips and tricks for shooting anything, anytime, anyplace with your beloved iPhone.

Certainly, the iPhone owns the everyday-photography space, while DSLRs own the commercial space, but these worlds are colliding faster than anyone expected or predicted. I can't wait to see what the future holds!

STYLE — **DSLR** VS. **iPHONE**

STYLE	DSLR	iPHONE
SELFIES	DON'T EVEN TRY IT	PERFECT
INDOORS	YES	MEH.
SPORTS	YES	IT'LL DO IN A PINCH
PORTRAITS	YES	YES
NATURE	YES	YES
EVERYDAY	SURE...	BUT THIS IS EASIER
SOCIAL MEDIA	NAH	YESSIR!
ABSTRACT	YES	YES
FOOD	YES	YES
WEDDINGS	ABSOLUTELY	IF YOU HAVE TO

THE DAY STEVE JOBS DIED

"MY LIFE IS SHAPED BY THE URGENT NEED TO WANDER AND OBSERVE, AND MY CAMERA IS MY PASSPORT."

Steve McCurry

The day Steve Jobs died, October 5, 2011, I happened to be photographing content on the island of Lipari off the northern coast of Sicily. His passing moved me; inspired me to fixate, all day long, on the influence he had and the contributions that he made on the landscape of the photography world.

As you might expect, it was a moody day, but also magical in a way. It was a day that will live long in my memory. I found myself, photographically speaking, in the zone.

That solemn evening, after the sun went down and I had a chance to catch my breath, I wrote down three lessons that, to this day, still fuel and inspire my iPhone photography efforts.

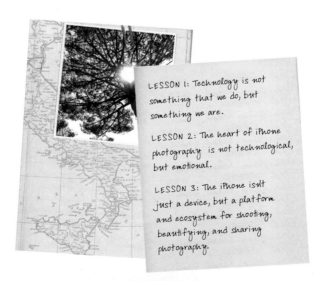

LESSON 1: Technology is not something that we do, but something we are.

LESSON 2: The heart of iPhone photography is not technological, but emotional.

LESSON 3: The iPhone isn't just a device, but a platform and ecosystem for shooting, beautifying, and sharing photography.

GETTING BETTER

Smartphone cameras are getting better all the time, and even the most casual observer of technology will realize that won't stop.

What's special about the iPhone is that, while each new version adds physical improvements (megapixels, lenses, etc.), the software that drives it improves at an even faster rate.

Technology has speedily advanced to the point that, by some measures, the quality you get is equivalent to a high-end professional camera from only a few years ago. One of those measures is the number of pixels that make up the image area, now almost exclusively referred to as megapixels.

Megapixels (MP) are important because a higher number means you can print the image larger without it looking soft (or you can select a smaller area of the picture and crop in).

Now, after five years of intensive shooting with the iPhone, my infatuation for it has turned into a mature love. I'm hooked. With the quality of images I can take with it now, I'm hard pressed to return to my big-camera days.

AVERAGE FILE SIZES OF A 12MP IPHONE

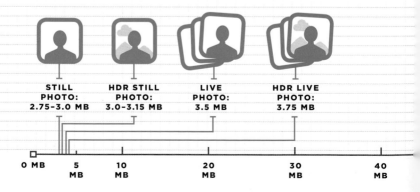

| STILL PHOTO: 2.75–3.0 MB | HDR STILL PHOTO: 3.0–3.15 MB | LIVE PHOTO: 3.5 MB | HDR LIVE PHOTO: 3.75 MB |

0 MB | 5 MB | 10 MB | 20 MB | 30 MB | 40 MB

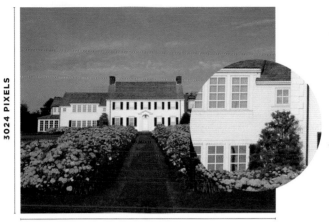

3024 PIXELS

4032 PIXELS

3024 ✕ 4032 — 12,192,768 = 12 MEGAPIXELS

The iPhone's high resolution allows you to enlarge and crop pixels without much degradation, and it's incredible for making large prints. (Yes, DO print your photos!)

The front-facing HD camera also makes a pretty good image. Its resolution is not as high as that of the main camera, but you can see the quality in selfies and Facetime calls. Awesome!

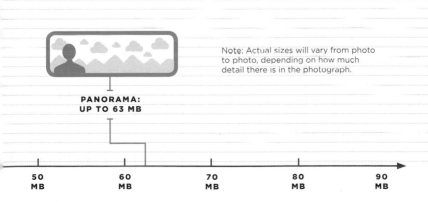

PANORAMA: UP TO 63 MB

Note: Actual sizes will vary from photo to photo, depending on how much detail there is in the photograph.

| 50 MB | 60 MB | 70 MB | 80 MB | 90 MB |

READY. SET. GO.

"GREAT PHOTOGRAPHY IS ABOUT DEPTH OF FEELING, NOT DEPTH OF FIELD."

Peter Adams

I'm assuming that you're ready to get busy taking cool pictures with your iPhone. I'm going to help you get there. Here are just a few things to be aware of.

Face, Blink, Smile Detection
Face detection is a default setting, so there isn't anything you need to do to activate it. You just need to be aware of it.

iSight Camera
This is the term Apple uses for their main, rear-facing camera on the iPhone, iPad, and iPod Touch.

Facetime HD Camera
This is the term Apple uses for their front-facing camera, also known as the "selfie" camera. Its specifications are lower than the that of the main camera.

Tap to Focus / Lock Exposure
In auto mode, the iPhone camera focuses on a subject or object that is in the center area of the display. For an off-center subject, tap the area you want the camera to focus on. To lock exposure, tap and hold.

Adjusting Exposure
The iPhone does not give you independent control over exposure. It bundles focus and exposure together. However, you can use the exposure compensation slider to over- or underexpose up to 4 full stops on either side of "correct."

HDR (High Dynamic Range)
You can turn the HDR feature on or off, depending on your taste. The camera takes three successive photos, each at a different exposure value, and applies some quick processing to combine the three exposures into one. The result is a photo with more detail that more closely mimics the way your eyes experience the scene.

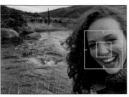

TAP TO FOCUS

ADJUSTING EXPOSURE

GEOTAGGING

Geotagging

You can turn geotagging on or off in settings (the default is on). Geotagging is basic location information that is inserted in the image file as metadata. I like using this feature to see a map of all of my photo locations. Quite amazing.

Editing Photos

The built-in Photos app is a powerful and intuitive way to edit and share. You can crop and rotate, apply a filter, adjust light and color, and a whole bunch more. The smart filter sliders are the bomb!

Burst Mode

Just hold down the shutter icon to capture 10 fps (frames per second). Release the shutter icon when you're done. It's a perfect tool for shooting fast-moving subjects. You can also use burst mode when you're shooting portraits and want to capture that perfect expression.

Time Lapse

The native iPhone camera app is capable of creating beautiful time-lapse videos. When you begin recording, the app captures at 2fps. When you play it back at normal speed (30fps), it's sped up. It's the perfect technique for shooting more-or-less static environments that change slowly.

Volume Buttons as Shutter Release

Did you know that you can use the volume buttons on your iPhone to trigger your shutter? For many, this feels more like shooting with a big camera. It can also help to prevent camera shake (resulting from tapping the screen too hard).

True Tone Flash

The flash on the iPhone is just a continuous-source LED light. But, it supports two different color temperatures: cool white and warm amber. When combined, these make very basic white-balance corrections. And, when using the selfie camera on the latest models, the retina display is a giant flash.

YOU ARE WHAT YOU SHOOT

"WHICH OF MY PHOTOGRAPHS IS MY FAVORITE? THE ONE I'M GOING TO TAKE TOMORROW."

Imogen Cunningham

Creating emotion in your photographs is the secret sauce for compelling images. You are trying to get others to feel about your pictures the same way you felt when you created them. You are what you shoot.

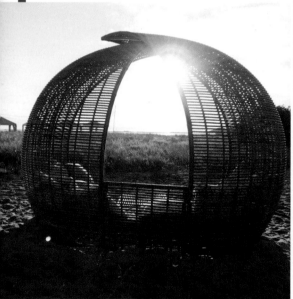

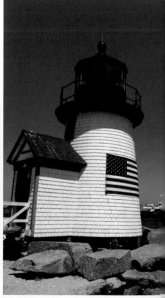

Your state of mind can affect how others will view your work. Here are a few of my own "feeling" favorites. Can you feel them?

WHAT'S IN MY MOBILE CAMERA BAG

"WHEN PEOPLE ASK ME WHAT EQUIPMENT I USE, I TELL THEM MY EYES."

Anonymous

I have tried so much gear. Still more gear sits in my closet untouched. There are just a few things I use regulararly. I want to share that list of items with you in the hopes of saving you some time and money.

MeFOTO field tripod and iPhone adapter
While you don't need tripods for most well-lit, outdoor scenes, a stable tripod does come in handy for interiors, low-light scenes, and special techniques like panorama, time lapse, and long exposures. If you use a tripod with your iPhone, you'll need the adapter too.

Joby mini-tripod and adapter
This is another premium tripod. It's sturdy, rugged, well built, and portable. It's the perfect travel companion.

Jackery portable high-capacity premium charger
If you don't have power, you don't have photos!

Moment attachment lens
There are literally dozens of attachment lenses on the market. But few, if any, are as good as the Moment lenses.

XShot selfie stick
This is one of the best selfie sticks on the market: It's compact, rugged, and waterproof.

iStabilizer gimbal / video stabilizer
This piece of gear isn't cheap. But, for mobile video, it's an invaluable asset for capturing ultra-smooth and steady footage.

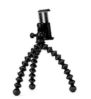

JOBY MINI TRIPOD

JACKERY PORTABLE CHARGERS

JACKERY ATTACHMENT LENS

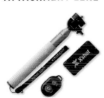

XSHOT SELFIE STICK

NOVA BLUETOOTH OFF-CAMERA FLASH

LEATHER BAG

RODE lavalier microphone
If you need an IOS microphone that is better quality that what comes bundled with the iPhone, this is a professional-grade wearable one that I love.

Camalapse time-lapse panner
This is such a useful gadget for creating smooth-panning time-lapse images.

Western Digital high-capacity hard drive
The worst thing you can do is to use your Camera Roll as a storage device. Don't! Get your photos and video off your iPhone and backed up to the Cloud or auxiliary hard drives like these.

Apple EarPods
What I love most about these is being able to trigger the camera shutter using their volume buttons.

Nova Bluetooth off-camera flash
This gem of an accessory allows you to use one or several flashes off-camera to give you that sculpted look.

Modahaus tabletop studio accessories
I own and use a half dozen of these tabletop units for small product photography. They are even portable enough to bring with me on the road.

ONA leather bag
If you are looking for a premium camera bag with style, look no further.

Native Union premium cables
I especially love their 10-foot charging cable. These cables meet the demands of an active, mobile lifestyle. And they're cool looking too!

Sandisk mobile storage
Here's the perfect mobile storage device to help you quickly and easily free up space on your device—up to 128 GB of additional storage capacity.

YOUR FIRST 10,000 PHOTOGRAPHS

"YOUR FIRST 10,000 PHOTOGRAPHS ARE YOUR WORST."

Henri Cartier-Bresson

Henri Cartier-Bresson, icon French photographer (1908-2004), considered by many to be the master of candid and street photography, used only one camera for almost his entire career: a Leica rangefinder with a 50mm lens.

To that end, this photographic master employed what so many smartphone photographers do today—spontaneity, simplicity, accessibility. So what exactly did Cartier-Bresson mean when he made that statement? And what does that mean to us today?

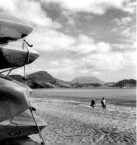

HERE'S TO
the next
10,000.

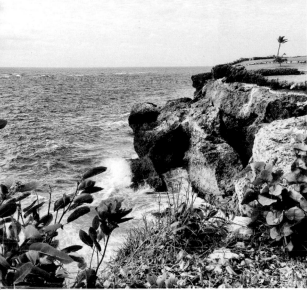

He was suggesting that, early on, it's so very important to develop good habits. Greatness is within anyone's grasp, but the tech part has to become second nature for creativity to dominate. Getting to the first 10,000 photographs is so much faster, cheaper, and easier now than it was for our analog counterparts.

I just recently completed a rough edit of my first 75,000 iPhone photos. What a great experience! As you might expect, the process yielded moments of jubilance and moments of embarrassment.

The point I'm making here, which I encourage you to embrace with open arms, is that when you're starting out, it's better to focus on the process of photography and not the product of photography. Hone your craft over time. The keepers will come!

Here's to your first, second, third, and fourth 10,000 photographs!

THE WORLD IS YOUR CANVAS

"A PHOTOGRAPH IS A SECRET ABOUT A SECRET. THE MORE IT TELLS YOU THE LESS YOU KNOW"

Diane Arbus

As I mentioned previously, my approach to iPhone photography is photographic. I want my photographs to look like photographs.

No matter what technological advancements or beautifying apps show up at my doorstep, they will always be greeted with professionalism and pleasantry. But, I don't want to make my photographs look painterly, or cartoony. I may follow and applaud visual trends as they happen, but I will always return to the heart of the matter: making and taking photos.

I am a crafter of light, both natural and artificial. I am a sojourning pilgrim using photography to celebrate life at every turn. I use my iPhone camera just like I used my DSLR— thoughtfully, intentionally, creatively.

In my big-camera days, I used Photoshop sparingly. I worked feverishly to get everything right in-camera instead. I still do! But just because I have a more photographic philosophy and methodology to my iPhone work than most doesn't at all mean I don't appreciate all the app blenders, stackers, and compositors out there. I do...immensely!

In the same spirit of celebrating art at every turn, I thought it would be appropriate to list of few of my own favorite apps. These are general apps that I use for all sorts of purposes. I'll discuss apps for more specific purposes later on. Here's to making the world your canvas!

PicTapGo
This is my go-to app for quite a lot of my mobile portrait work. Stackable filters, reusable recipes, and fast work flow.

Litely
Elegant photo-filtering app for discriminating mobile photographers. Film-inspired presets, beautiful interface.

LENS DISTORTION

Priime
Available for both iPhone and Mac. Over 100 gorgeous styles to pick from.

Lens Distortion
The overlays look real because they're made from optically captured elements.

PHOSTER

Phoster
Here's an intuitive app that will help you easily create poster art based on designed templates from pros.

Enlight
I'm a huge fan of their Urban Filters. Flower power, baby!

ENLIGHT

Tiny Planet
Turn your photos into Tiny Planets, Rabbit Holes, and amazing videos in one tap. These tricks would normally take hours to do in Photoshop.

TINY PLANET

Waterlouge
You don't need to be a painter to create fine art. This app is absolutely brilliant!

PIcFX
I love this app for adding grunge and textures to my photos.

WATERLOUGE

After Focus
A super simple app for creating out-of-focus backgrounds in your photos.

Filters for iPhone
This app has over 800 filter combinations. And so many of them are rockin' awesome!

PIC FX

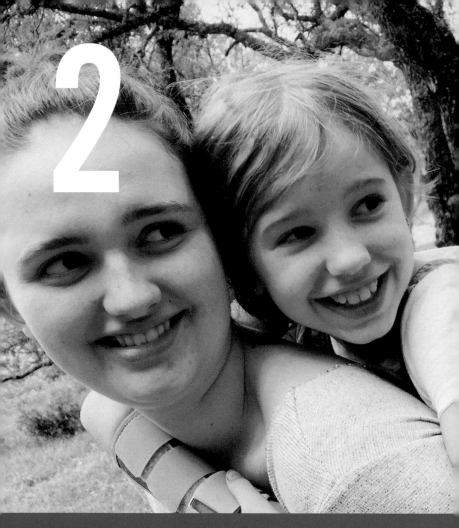

2

PHOTOGRAPHING ALL THE
BEAUTIFUL
PEOPLE IN YOUR LIFE

"IT'S ONE THING TO MAKE A PICTURE OF WHAT A PERSON LOOKS LIKE, IT'S ANOTHER THING TO MAKE A PORTRAIT OF WHO THEY ARE."

Paul Caponigro

After nature, people are the second most popular photography suject. People pictures, for the most part, fall into two broad categories: portraits and candids.

Portraits are made with your subject's awareness and cooperation, while candid shots are normally taken without posing. In general, portraits are formal and candids are informal. I have come to realize that people photography done with an iPhone feels more like a natural part of the conversation rather than a set-up shot.

Photographing all the beautiful people in your life, whether portraits or candids, is not the place for perfectionism. Just get the shot. So what if it's not perfect? At least you have it!

Get out of your shell and make the photographic experience more about the person you're photographing and less about you. The more confident you become, the more powerful your pictures will become.

The iPhone, more than any camera I have ever held in my hand, is the ideal tool for creating precious memories of those we love. That spark in the eye, that burst of joy, that resonating beauty... is all only a click away. Don't let those precious seconds fly by without some sort of record of your time together.

LET ME TAKE A SELFIE

Across the world, people take more than one million selfies a day, or upwards of six per person. Snap-happy American millennials—men and women equally—fuel this obsession.

Oxford Dictionaries deemed "selfie" the 2013 Word of the Year. 2014 was declared by Twitter the Year of the Selfie. Shooting and posting selfies is no fad. It's mainstream and here to stay.

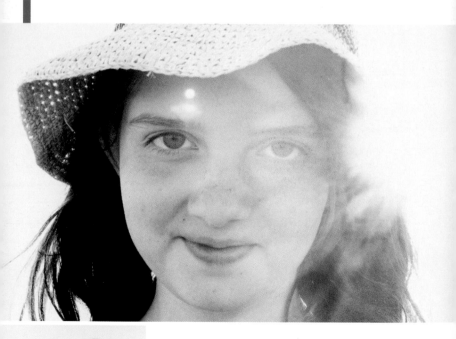

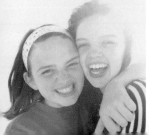

Shoot from just above eye level
FOR THE BEST ANGLE.

Is this preoccupation a form of self-absorption, or self-expression? I lean toward the latter. Selfies are way to express one's own voice and vision...and here's hoping we each also find validation through healthy introspection, not just through likes, follows, and comments!

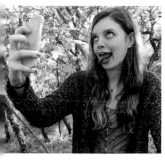

Make each selfie more about context AND LESS ABOUT YOU.

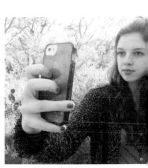

Make sure your face is illuminated, BUT STAY OUT OF HARSH LIGHT.

Look at the lens TO MAKE EYE CONTACT WITH VIEWERS.

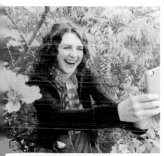

BE CASUAL, AND **have fun.**

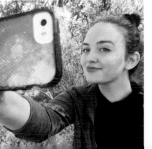

Extend your neck forward TO ACCENTUATE YOUR JAW.

AT ARM'S LENGTH

Thanks to smartphones, we are all happily committed to the idea of chronicling our daily lives through pictures. And, because life is full to the brim with living, breathing relationships, that means healthy doses of couple and group selfies.

I laughed out loud as I was researching this chapter and discovered that selfies of couples are called relfies (relationship selfies) and a group selfie is referred to as an ussy (rhymes with fussy). Group selfies seem to carry more social credibility than the individual selfie since they display relationships, both actual and implied.

Taking a group selfie is a whole different can of worms than taking a solo selfie, for the sheer fact that you have to cover a bigger field of view in the photograph. Add to that the challenge of dealing with assorted expressions, heights of subjects, personalities, moods, etc., and group selfies are not for the faint of heart!

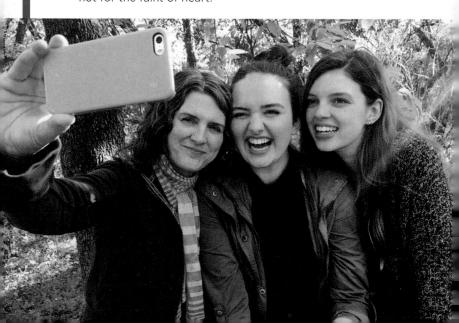

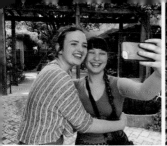
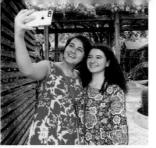

Shoot wide
TO INCLUDE
EVERYONE. TRY
A SELFIE STICK OR
WIDE-ANGLE LENS
ATTACHMENT.

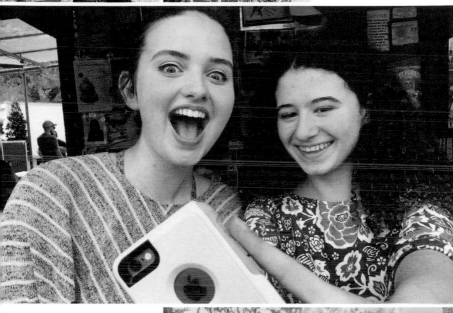

Lock exposure:
TOUCH AND THEN
LONG-PRESS THE
SPOT YOU WANT
TO EXPOSE FOR.

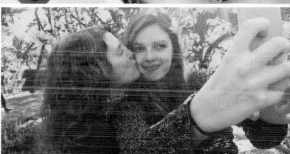

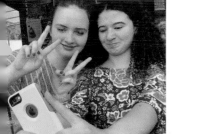

MAKE SURE EVERYONE'S FACE
IS IN THE SAME LIGHT.
Open shade is a safe bet.

MORE THAN A PHOTOGRAPH

You have to love how Apple thinks: Always pushing the envelope, always trying to find a new sweet spot for the consumer photographer.

There is ongoing debate here whether Live Photos is genius or just a fad. I'm in the former camp and truly believe that technology like this will help help redefine the very nomenclature of photography.

Live Photos is a novel camera feature that literally brings still photographs to life. When activated on your iPhone, it will begin recording video immediately. Once you press the shutter, Live Photos will save the 1.5 seconds of video from before and 1.5 seconds after the still photo you took. So, you experience the whole sensation: photograph, movement, and sound. And it's all activated seamlessly with 3D Touch.

Technically speaking, Live Photos is neither video or a GIF, but an animated GIF in JPEG format. These Live Photo creations appear in your Camera Roll along with all your other photos, but with extended media attached to them.

What subjects are best for Live Photos? The answer will likely depend on what and how you shoot. For me, by far, the best application is for photographing people, especially young children. Experiment with it, have fun. It's great for shooting street scenes, cherishing little magic moments with friends, showing a 360° view of an interior or a vista, capturing leaves blowing in the breeze, or taking dynamic selfies and portraits.

It's a good idea to keep Live Photos turned off until you have a scene or subject that calls for it, because the files take up about twice as much space as still photos.

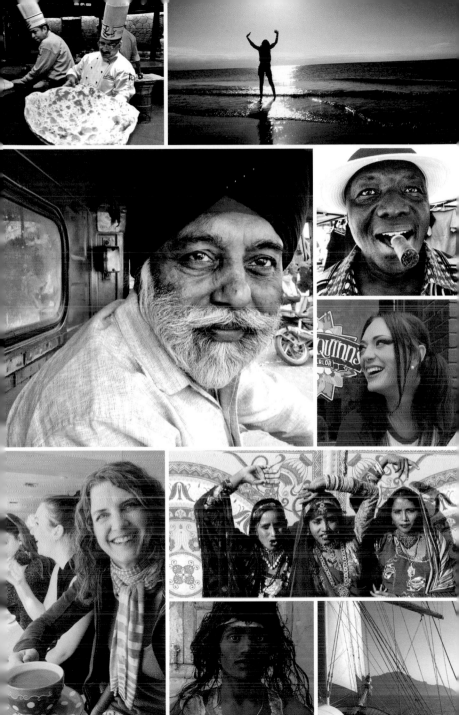

BEST FRIENDS FOREVER

Millenials, or "digital natives," as some call them, have their own visual vocabulary. They grew up under the trilogy of the Internet, mobile technology, and social media. How does this shape their experience of photography? It has not been an academic pursuit to be mastered, but a relational experience to be shared and celebrated.

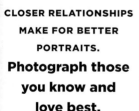

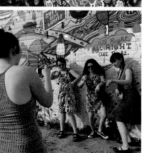

It's all about content and message.
QUALITY IS FAR LESS IMPORTANT.

CLOSER RELATIONSHIPS MAKE FOR BETTER PORTRAITS.
Photograph those you know and love best.

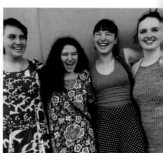

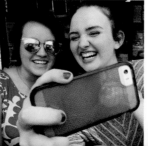

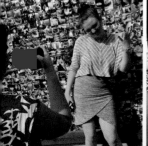

TO ENSURE LOTS OF INTERESTING SHOTS, CHOOSE A fun location.

I have two teenage daughters. They are the brightest luminaries in my photographic galaxy. Since birth, they have been both in front of and behind my camera. Watching them now with iPhones in hand, photographing their own friends, is sheer joy for me. It seems effortless, uncomplicated, and fluent. Their photographs of each other are natural and intuitive.

I thought it would be fun to follow them and their friends around while they photographed each other for a few hours, and observe how they do it. I want to share with you what I learned that we might all apply when photographing our own BFFs. Follow me!

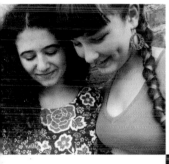

Let down your guard.
FOCUS ON CAPTURING THAT BEAUTIFUL MOMENT.

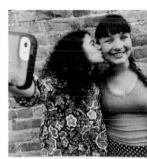

HAVE THE SUBJECT
look out of frame
TO CREATE INTRIGUE.

Use burst mode
TO CAPTURE A VARIETY OF EXPRESSIONS.

LIFE IS MESSY

I don't know about yours, but my life is messy. It always has been, and I suspect it will be until I leave this good Earth. But messy is good, in a photographic sense. It's something to be embraced and celebrated. It's right in the middle of the messy stuff that you're likely to find your most cherished moments.

It's been quite a long time since I've had little ones around the house, but the fond memories of those special days are as strong and vivid today as they were decades ago when I experienced them. I was one proud papa, and my girls have to be two of the most photographed children in history.

Photographing babies, toddlers, and children follows the same rules as your big-people pictures. Approach with caution and get the subject comfortable with you being in their territory. Work slowly and deliberately. Know a little something special

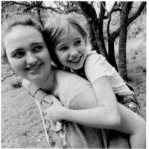

Turn the flash off.
IT'S DISTRACTING
FOR KIDS.

**THE LATEST
iPHONES CAN
capture stills
while shooting
video.**

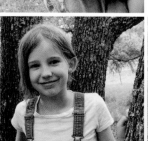
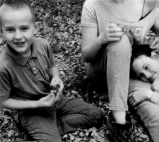

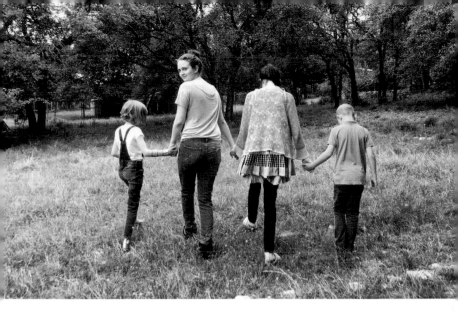

about your subject's habits, quirks, and whims. Maintain eye contact and speak softly but joyfully. Shoot at eye level. Shoot as quickly as possible, while the moments present themselves. And finally, minimize tech: Keep it as simple as possible.

Choose the best light.
OUTDOORS FIRST, WINDOW SECOND, ARTIFICIAL LIGHT THIRD.

Get lots of shots.
CHOOSE YOUR FAVORITES LATER.

LIFE, CAMERA, ACTION

Lifestyle photography is meant to be inspirational and aspirational. To put it simply, it's the art of photographing everyday people in everyday environments, expressing everyday emotions.

The key to lifestyle photography is to create images that look and feel real, authentic, and believable. The degree of naturalness in a series of lifestyle photographs often grows directly out of the relationship between subject and photographer.

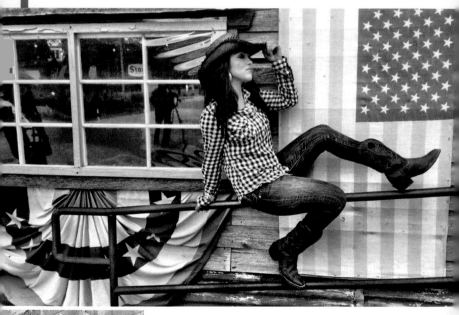

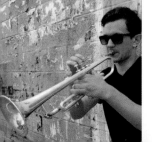

Posture makes the mood
OF THE PHOTO. ASK YOUR SUBJECT TO STRETCH, TWIST AND TURN, MOVE AROUND, BE LOOSE.

Lifestyle photography, as opposed to traditional portraits, is more contextual in nature. In other words, it's not at all uncommon in lifestyle photography to pull the camera back and show details of the scene surrounding the subject.

There will always be, in this style of photography, a certain creative tension for the photographer to observe and capture (follow the action as it unfolds) versus a direct-and-capture approach (plan and set up the action). And, while I no doubt miss having a big pro camera for this style of photography, I will be the first to admit that I appreciate the compactness and inconspicuousness that the iPhone camera offers.

Look at these photographs for yourself. Don't most of them seem like I was just hanging out and capturing an artful record of our time together? When I shoot with the iPhone, I am able to move through a scene so very smoothly and quickly. It feels like I'm more of a participant and less of an onlooker. That fact alone greatly increases the likelihood that my lifestyle images will generate a natural sense of belonging and attachment.

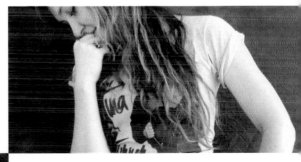

Relax.
THIS WILL HELP YOUR SUBJECT RELAX AND BE THEMSELVES.

Make eye contact
WITH YOUR SUBJECT. THE iPHONE'S COMPACT SIZE LETS YOU DO THIS!

LIFE IN MOTION

I know, this is a book about photography. But in the mobile space, it's awkward, impossible even, not to talk about video. I am sure that next-generation storytellers, especially in the mobile space, will be less obsessed with the medium and more about the content they're creating. I see this clearly in the way my teen daughters use their iPhones, in still and video modes, to create personal narratives and memories.

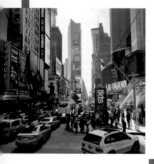

Lock your exposure.
THAT WAY, THE ENTIRE CLIP, FROM BEGINNING TO END, WILL HAVE THE SAME TONAL VALUES.

Use both hands.
STEADY AS SHE GOES.

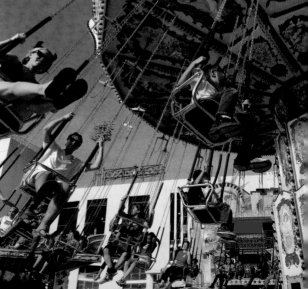

Video. I shoot a lot of video, all the time. As a matter of fact, looking back over the last five years of shooting with my iPhone camera, I'm noticing more and more that I shoot video right alongside my stills. It's natural, simple, fun, and high-quality! Plus, it doesn't require a ton of tech learning to get it right.

Slo-Mo. This mode captures a slow-motion video. Trust me, this feature is really remarkable. I shoot Slo-Mo all the time. Try it handheld (no tripod). It's creamy and buttery and creates such a big wow factor with viewers.

Time-Lapse. Time-lapse was introduced in iOS 8. It captures 2 frames per second, combines all the images into a video clip, and plays it back at 30 frames per second (15x factor than actual speed).

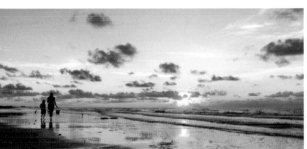

FOR THE MAJORITY OF PLAYBACK OPTIONS, IT'S BEST TO **shoot your video in the horizontal (landscape) orientation.**

IF YOU DON'T LIKE WHAT YOU SEE... **shoot it again** (AND AGAIN AND AGAIN).

THE NEW FAMILY ALBUM

Let's face it: The nuclear family has changed a lot in the past few decades. So why wouldn't the family album evolve right along with it? It has! Camera Roll is the new family album.

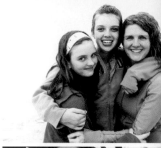

We have ditched the romantic notion of memorializing our family moments and memories in print, and instead have opted for the convenience and practicality of bits and bytes...and why not?

With the iPhone camera, and its Camera Roll app, I can create a modern family album and happily share it anytime with anyone who will indulge me. It's certainly faster than what my parents used to drag out of the coat closet, and we're looking at everything on a high-quality Apple retina display, wherever we happen to be. Awesome!

Don't wait for milestones.
CAPTURE ALL THE EVERYDAY MOMENTS. YOU WON'T REGRET IT!

I photograph the heck out of my family. I never get tired of it. As a matter of fact, they are probably my all-time favorite subject.

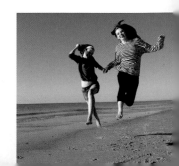

Who better than you to get those priceless, precious snaps of your family as they dance through the rhythms of life? You are the family photographer, and Camera Roll is your archive! (Do be sure to back it up every few weeks, though.)

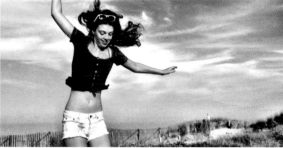

SHOOT A SERIES OF PHOTOS TO tell a family story.

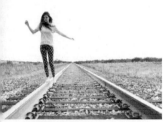

Print your favorites AND HANG THEM ON THE WALLS!

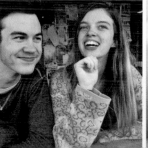

3

MOMENTS & MEMORIES

"LIGHT GLORIFIES EVERYTHING. IT TRANSFORMS AND
ENNOBLES THE MOST COMMONPLACE AND ORDINARY
SUBJECTS. THE OBJECT IS NOTHING, LIGHT IS EVERYTHING."

Leonard Missone

We find beauty and charm in commonplace things and ordinary people. From the beginning of photography, we have always shot everyday subjects and themes, but at nowhere near the volume or intensity that we see today.

Old-timers like me called this type of everyday shooting "vernacular photography," since it was mostly shot by amateurs and unknown professionals who took pleasure in documenting and interpreting everyday life and common themes.

Smartphones currently outsell dedicated cameras almost ten to one. Expect that number to significantly rise over the next decade. The overwhelming majority of consumers and "prosumers" today take photographs with their smartphones. And, the subject that this mobile majority is shooting is routine glimpses of life.

While the vast majority of vernacular photography shot today will not stand the test of time in an artisitic sense, I can't help but feel gleeful about each of us using our iPhone cameras to chronicle each day's artful moments and memories. I do believe it will leave this world a richer, fuller, and more beautiful place than when we arrived.

IMMORTALIZING EMOTION

It may seem like I'm spending a lot of time talking about emotion in photography. I am, because infusing your photographs with emotion is the very heart of your task.

When it comes to photographs, there are two kinds of emotion: viewer emotion (how the viewer feels when they look at your photo), and photographer emotion (your backstory, the emotions and circumstances behind capturing the images).

Will every photograph you take be teeming with emotion? Hardly. That's unrealistic. But when you find a scene or subject that is pregnant with emotional possibilities, do slow down and spend the extra effort to get the shot.

Our own mood absolutley influences the messages we create. Every time I pull my iPhone camera out of my pocket, I do a quick attitude check. Joy begets joy. You'll find that when your spirits are right, your photographs are right!

I love how certain photos make me feel—a sexy smile on my wife's face, a twinkle in the eyes of my two daughters, the color red, deep shadows, beachscapes, the open road, tantalizing plates of food, sunrises and sunsets, infinity pools. I'm sure you'll have your own special list of subjects that stir your sense of beauty. It's important to discover them. Shoot them over and over again. Make a them a part of your life.

Creating an emotional connection with what you shoot is as central as it gets in photography. The greater your emotional connection to the things you photograph, the greater chance you'll have at influencing emotion in others with those images.

Angle of view, perspective, and field of view can be used to great effect to convey your emotion and evoke the viewer's.

CAMERA ANGLES

WORM'S-EYE VIEW

HIGH ANGLE

BIRD'S-EYE VIEW

POINT-OF-VIEW

Normal. The camera is at the subject's eye level. This is how we see the world with our eyes. Careful not to overuse this one, or your photos will look predictable.

Low. The camera is set below normal, shooting up. This angle can exaggerate an element to make it appear larger.

Worm's-Eye View. Very low angle, like an actual worm.

High Angle. Above normal, shooting down. This can make the subject look smaller or less significant.

Bird's-Eye View. My favorite, and sometimes the hardest to get. The camera is directly over the subject. It can show quite a bit of context in the frame.

Point-Of-View (POV). As seen through the eyes of a particular "character." It shows the viewpoint of that person.

Dutch Angle. The camera angle is tilted, not straight. It is used to create movement, redirection, or sometimes tension.

FIELDS OF VIEW

EXTREME WIDE

EXTREME CLOSEUP

Extreme Wide. The purpose here is to give a general impression of a scene.

Wide. Shows the scene at life-size.

Medium. Coomon for protraits. Captures the subject from the knees or waist up, balancing content with context.

Closeup and Extreme Closeup. Probably requires a macro attachment for your lens. Remember, if you get too close to your subject, you'll likely accentuate and exaggerate features.

DOCUMENTING VS. INTERPRETING

Each time we capture a photo, we make the decision, almost unconsciously, of whether to approach it literally or figuratively.

The literal approach (by far the most common) is for documentation, a physical description of something. The figurative approach (the more elusive of the two) is an interpretation, expressing deeper or tangential meanings. Subject versus concept.

For example, doors and windows are some of the most photographed of all subjects, all around the world, across all cultures and races. Why? Is it because they're interesting to look at? That's part of it. But I think there is a more emblematic meaning too. Doors and windows, in addition to their physical characteristics, are symbolic.

They beg to be opened and entered into. They represent broader concepts like home, belonging, warmth, exploration, pilgrimage, wandering, and passage. You can think of doors and windows as subjects, or you can think of them as concepts.

Concepts are abstract and harder to get your head around. But once you begin to look at the world in this different way, a new appreciation of visual delight will open up to you, one that you could not have imagined.

This is where photography really starts to get fun. Maybe one day you feel like a photojournalist and only want to document things. On another day, you might prefer a more allegorical approach to your shooting and find yourself looking more broadly at the conceptual meanings attached to your subjects. See if you can pick out some conceptual meanings for yourself to hone in on.

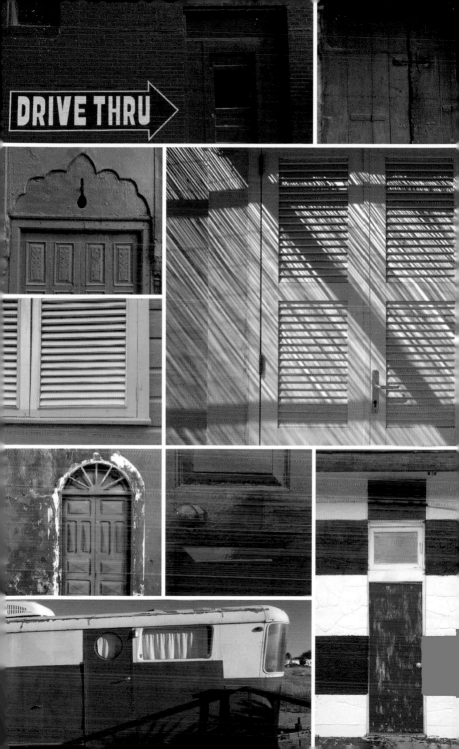

#FROMWHEREISTAND

"...IF A PHOTOGRAPH IS HONESTLY MADE, IT'S A BIT OF A SELF-PORTRAIT. I THINK IT'S IMPOSSIBLE FOR A PHOTOGRAPHER WHO IS WORKING HONESTLY TO KEEP THIS FROM HAPPENING."

John Sexton

Having our own point of view is in photography is everything. It's exactly why most of us shoot—to put our own personal voice or perspective on the faces, places, and spaces of this world.

The longer you're at it, the more distinctive your point of view will become. And, more people will recognize it. While mimicry in photography is a great place to begin, once you have a few thousand exposures under your belt, your own take on the world should start to emerge.

Look down.

THE BIRDSEYE VIEW CAN REDUCE A PHOTOGRAPH TO ITS BASIC ELEMENTS OF COLOR, SHAPE, TEXTURE.

The good stuff in photography, and I mean the really good stuff, is not found in imitation, but in invention. I can think of no greater contribution you can make to mobile photography today than to just be yourself. It will make your photographs stand up and stand out. And, without a doubt, separate you from the masses.

I just love the (literally) point-of-view images I find in the hashtag #fromwhereistand. It's a widely beloved community, and for good reason. The feed is full of people with catching, real-life perspectives. These photos are less self-absorbed than the traditional selfie-takers. It's a brief but delightful photographic intersection of humanity, nature, and fashion.

Try it!
SHOOT #FROMWHEREISTAND CONTENT ALL DAY ONE DAY. SEE WHAT YOU CAN COME UP WITH.

Caption your photos
TO AROUSE CURIOSITY AND FASCINATION IN YOUR PERSONAL NARRATIVE.

THIS IS THE TIME OF YOUR LIFE

Having precious and priceless documentation of events, celebrations, and traditions is a primary purpose for photography. Who we are is partly a reflection of milestones that mark our passage. The iPhone, however, has some limitations in this area.

I hope not to lose some of you here, but it would be insincere to suggest that the iPhone is the perfect capture tool for recording every life event. The iPhone shines the brightest when you are shooting well-lit subjects in natural light (generally outdoors). It struggles a bit in artificial or low light.

IF YOU FIND YOURSELF SHOOTING PRIMARILY INDOORS, THEN use a tripod TO AVOID BLURRY SHOTS.

Since so many life events are indoors, let me suggest you invest in an off-camera flash, a tripod with an iPhone adapter, and a third-party app like Camera+ that gives you white balance control...or use a compact camera or DSLR.

Am I suggesting that the iPhone camera is not capable of shooting indoors, in artificial and low-light situations? Not at all. It just doesn't do it as well as a dedicated camera can, at least not yet.

I would rather trust these major life memories to a dedicated camera with a full-frame sensor, interchangeable lenses, manual controls, flash, and high ISO capability. For outdoor events, however, the iPhone camera is more than adequate to make you look like the family photographer rock star that you are!

GET IN TOUCH WITH YOUR INTERNAL PHOTOJOURNALIST AND DOCUMENT. DON'T OBSESS OVER CREATING ART. Just get the shot!

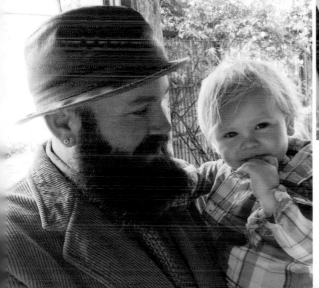

Capture as many family and friends as you can. YOU'LL BE GLAD TO HAVE THOSE PHOTOS YEARS FROM NOW.

BECOME A FOODIE PHOTOGRAPHER

Food photography is enormously poplular in social media, particularly on Instagram. Several years, hundreds of hashtags, and millions of photos have proven it.

I'm definitely a foodie photographer these days. Besides road tripping and family portraiture, it ranks right up there with my favorite genres. Whether I'm at home or eating out, I'm always on the hunt for that special food shot.

The way we eat and how we share it not only reflects our personal taste and sense of choice, but it can also be a function of class, gender, ethnicity, and even generational status.

Food offers a universal language of sorts. It's a common subject we can all relate to, no matter what our culture. It brings us together, nourishes us, makes us happy, and connects us to memories. Can you think of anything that unites more?

My grandmother, a Russian immigrant, was an awesome cook. To this day, I can still taste her homemade beans and smell the aroma of turkey in the oven. It's a powerful and comforting memory. We have the opportunity with our own food photography to uphold these lasting memories among our family and friends. Bon appétit!

Check out these Instagram hastags for some great food photography.

#food	#yummy	#foodporn	#instafood
#delicious	#foodie	#eat	#foodgasm
#foodpic	#cooking	#snack	#recipe
#cook	#healthy	#fresh	#sweet
#homemade	#hungry	#yum	#foodphotography

Let go of perfection.
NOT EVERY SHOT WILL BE A WORK OF ART.

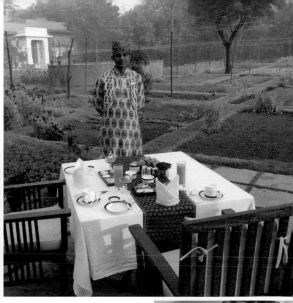

Try widening some shots
TO SHOW MORE THAN JUST THE FOOD AND CREATE A NARRATIVE.

Make sure the color looks right
SO THE FOOD LOOKS APPETIZING.

4

WINDING DOWN

> **"LIFE IS NOT MEASURED BY THE NUMBER OF BREATHS WE TAKE, BUT BY THE MOMENTS THAT TAKE OUR BREATH AWAY."**
>
> *Dr. Bob Moorehead*

For a time, I had lost the joy of photography. Photography was my business, and I was preoccupied with making a profit. Thanks to my iPhone camera, the joy has returned in full force.

It's inevitable—the frantic pace of life we live can overwhelm our creative impulses, despite our best intentions. We need to preciously guard against this and use our weekend time (or any leisure time) to creatively unwind.

To me, the most rewarding part of unwinding with my camera over a weekend is documenting and interpreting life experiences. This is the heart of joyful photography. The more you do, the more joy you'll get out of the process.

If a photographic opportunity gets you to look at something a little longer than you normally would and shoot it, then it's done its job. This is what weekends and winding down is all about. It's your time, and it's right now.

If you have photographic eyes to see, then the weekends could be full of moments that take your breath away.

DESIGN WITHIN REACH

Composition is known in the visual arts as the intentional arrangement of elements in a piece to provide a natural path for the eye to follow through the photograph. Done right, it will infuse your photography with feeling and fluidity.

Composing mood-provoking photographs may seem, at first glance, a piece of cake. However, it takes dedicated practice and tireless experimentation to understand the elements of design and the techniques that bring life to them.

The goal is to bring subject and composition together in a photograph. We won't all compose our photographs in the same way because, in large part, how we see the world depends on what we are interested in.

Including texture,
LIKE PINEAPPLE SKIN OR BROCCOLI FLOWERS, MAKES A REALISTIC AND ENGAGING PHOTO.

Leave space enough for a photograph to "breathe"
AND FOR THE EYE TO TRAVEL. THIS MIGHT MEAN CROPPING YOUR SUBJECT OFF-CENTER.

Take a good look at the market photographs below. Do you feel something? Do you want to know more about the subject? Is your mouth watering? Are you moved to make a purchase? Good composition creates feelings, and feelings influence actions. That's exactly what you're looking for here.

Farmers markets offer a smorgasbord of visual delight: lines, shapes, colors, textures, forms, and depth. So, next time you visit one, consider doing so, not necessarily to shop, but to explore the basic principles of composition and how it can create feeling and atmosphere in your photographs.

Complementary colors
(OPPOSITE EACH OTHER ON THE COLOR WHEEL) ARE VERY ENGAGING.

ODD NUMBERS ARE **more comfortable to the eye** THAN EVEN NUMBERS.

POETRY IN PICTURES

"CONSULTING THE RULES OF COMPOSITION BEFORE TAKING A PHOTOGRAPH IS LIKE CONSULTING THE LAWS OF GRAVITY BEFORE GOING ON A WALK."

Edward Weston

If you think about it, what makes a photograph beautiful is generally attributed to composition—a process that relies on emotion, feelings, and intuition more than on logic and calculation.

Good composition can make even the most mundane objects and subjects magical or spellbinding. Bad composition, on the other hand, can ruin a photo, regardless of how great its content is. The good news is that composition can be learned through rehearsal and repetition. The not-so-good news is that it's a process that takes time to learn.

EVERY PHOTO NEEDS A primary resting stop for the viewer. MANY PHOTOS ALSO HAVE SECONDARY POINTS OF INTERESTS.

DIAGONAL LINES GIVE A PHOTOGRAPH A SENSE OF action, direction, and movement.

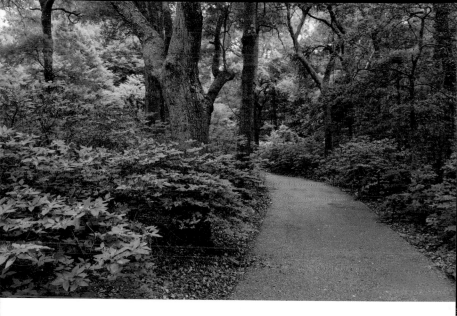

Teaching new photographers to see and compose photographs is very challenging. For photographers, it's one of the most difficult things to effectively learn. But, over time, with a healthy dose of patience and childlike discovery, the principles of composition will eventually begin to seem as natural to you as inhaling and exhaling.

USE LAYERING TO GIVE YOUR PHOTOS DEPTH. INCLUDE POINTS OF INTEREST IN THE **foreground, mid-ground, and background.**

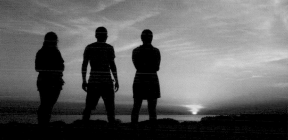

GARDENS, YARDS, PARKS

"PHOTOGRAPHY IS AN ACT OF OBSERVATION. IT HAS LITTLE TO DO WITH THE THINGS YOU SEE AND EVERYTHING TO DO WITH THE WAY YOU SEE THEM."

Elliott Erwitt

My advice for photographing gardens is as follows: Instead of trying to capture the whole scene in a single shot, try breaking the scene down into smaller bite-size photographs. Better to have a handful of properly exposed photos than one giant ugly one.

You would think that photographing gardens, yards, and parks would be the easiest thing ever. Yes, in that all three of these locations are photogenic and naturally beautiful. No, in that the dynamic range of these scenes often exceeds the dynamic range of the iPhone sensor; clipping of either highlights or shadow areas is likely.

Find an angle to shoot from
THAT ELIMINATES OR LIMITS DISTRACTING BACKGROUND ELEMENTS IN THE FRAME.

Generally speaking, the worst time to photograph gardens, yards, and parks is 90 minutes on either side of high noon. That's when the light is harshest and yields the least amount of scene color and saturation. The most dramatic time to shoot is a couple of hours after sunrise or before sunset.

More often than not, it won't be the wide shot that gets the most ooohs and ahhhs. Instead, it will be those quiet vignettes of pattern, detail, texture, and shadow.

Remember, it's not enough to show the viewer what the subject looks like. You need to show what it feels like.

Move in close
AND FILL THE FRAME
WITH THE SUBJECT.

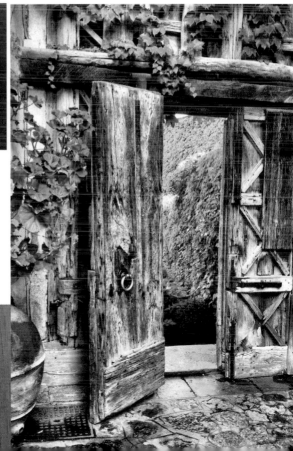

ROAD TRIPPING

"IF YOU WANT TO BE A BETTER PHOTOGRAPHER, THEN STAND IN FRONT OF MORE INTERESTING STUFF."

Jim Richardson

Road tripping ends up being about the journey as much as the destination. It is where the process of photography is as important as the product. It's full of discovery and aha moments.

As human beings living on planet Earth, most of us do not spend enough time alone—time to think, meditate, or commune with nature; time to learn, grow, and develop into our own unique, one-of-a-kind selves. I have a solution for this: travel!

Not just any travel—I'm talking about being on the road for the express purpose of intentional photography. It's a rush, and an experience I try to have several times a year. It's one of those sacred, protected activities in my life that gets me focused. Road tripping can be so therapeutic.

It can be meticulously planned or totally spontaneous. The only planning I do for these sort of trips is my starting and ending point. The rest I leave to chance and fate. Regardless of how you plan, just get going!

One of the key reasons road tripping is such a powerful experience is that it connects you with your inner voice and vision. Our daily lives are surrounded by voices. We hear them when we wake up and when we go to bed. This bombardment of voices often drowns out the most important voice of all: your own voice, your creative intuition. This is bad news. Your own voice is the most important one when it comes to your art. Think of this voice like your best friend—listen and learn.

This is my personal list of favorite road trip subjects:

- Signs (especially vintage signs)
- Food (I shoot everything I eat)
- The open road
- Light and color
- Landscapes
- Roadside abandoned buildings and shacks
- Small towns
- Americana
- Anything retro
- Antique stores
- Roadside vendors
- Highway fruit and vegetable markets
- Sunrise and sunset
- Portraits (candid and staged)

FAUX VINTAGE

I don't recall in my photographic lifetime, there ever being such infatuation with faux-vintage as there is today. Retro is in. Vintage is in. The analog look is in. Hipstamatic and Instagram started it all, and there's no stopping it.

I think it's a nostalgic reaction to digital perfection among dedicated camera enthusiasts. Digital is inherently a bit too perfect. This kind of faux-vintage look connects us emotionally to our past—perhaps an even simpler and gentler time with less tech and more touch.

Looking back, even since the advent of the digital era, I was never known to be a Photoshop guy. I always wanted my photographs to look like photography, which in my view, means minimal post-processing. I did my best to get it right in-camera.

But I do find myself attracted to faux-vintage filters and apps, and I'm even relatively heavy-handed in my use of it them, when the subject calls for it. As much as I enjoy faux-vintage filters, however, they arent meant to be randomly applied to everything. Let the subject be your guide.

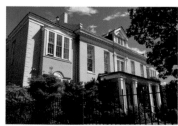 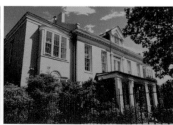

SHIFT BEFORE **SHIFT** AFTER

My Favorite Vintage Apps

- **Film simulation:** RNI Films, Camera Bag 2, Tin Type
- **Vintage/Retro:** Hipstamatic, Lo-mob, Vintique, Mextures, PicFX, Distressed FX
- **General:** Filters for iPhone, Shift

CAMERA BAG BEFORE

CAMERA BAG AFTER

DISTRESSED BEFORE

DISTRESSED AFTER

LO-MOB BEFORE

LO-MOB AFTER

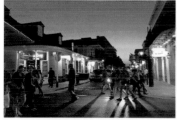

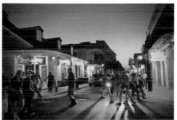

VINTIQUE BEFORE

VINTIQUE AFTER

THE CURIOUS SHOPPER

On a recent weekend wind-down, I shot antiques and collectibles, some outdoors at flea markets, and some inside antique stores. I was impressed by how well my most recent iPhone performed in the low light.

With earlier iPhones, you had to get lucky to get a good indoor shot, or really spend time and work hard to get something usable. Not anymore. With just a few simple tips you can do pretty good indoor photography, even in low light.

**Use a
tiny tripod.**
IT'S A GODSEND!

**Use your
elbows as a
pseudo-tripod,**
FIRMLY RESTING
THEM ON A
FLAT SURFACE.

By nature, flea markets, despite being outdoors, are pretty cluttered, often chaotic. What looks good to your eyes may not look so good to the camera. Your eyes can see a much wider range of light values than the iPhone camera can capture, so you really have to work hard at narrowing down the focal point.

The focal point of a photograph is, in most cases, the most important element in the frame. The more complicated the scene, the more time you need to take to properly highlight that subject. A flea market or antique store is not the place to quickly and blindly fire away. You have to slow down and put some thought into what you are shooting.

Just like at farmers markets, ask permission. It's professional, and people generally appreciate your interest and enthusiasm. Sneaking around is creepy.

This type of photography, at least in my own experience is more about finding shots than staging them. This is the perfect place to put your photo-journalism cap on and try building a story around a single image or series of images. The indoor photos especially are likely to need some post processing.

To further prevent blurriness,
CONNECT YOUR EARPODS
AND USE THE VOLUME BUTTONS
as a remote shutter release.

TEXAS STATE FAIR

When I use my iPhone to shoot amusement parks
or fairgrounds, the very last thing on my mind is to
document the whole thing. All I'm really trying to
do is to capture a mood, a spirit, a feeling, something
to look back on and remember what a good time
I had with family and friends.

The Texas State Fair is an annual event that happens in Dallas
in the fall at historic Fair Park. I look forward to it every year.

Just like in other family outings, I subjugate my photography
interests to the overall family interest and itinerary. Rather than
try to cover too much (something I might do if I were alone),
I go right after the key shots that I know will make a nice record
of our family time at the state fair.

I think it is far better in this kind of setting not to lug around
a big camera and accessories. The iPhone is the perfect device
for events like the fair.

That said, I personally think the iPhone camera has a tendency
to overexpose most things. That's why I love and almost
obsessively use the exposure compensation slider to get the
final photographs looking and feeling exactly like I want.

I like to slightly underexpose my photos at the fair, because
there is so much blue in the Texas sky, and I generally want my
colors to pop. This way, the images look just a bit darker and
more saturated than what the iPhone camera thinks is "correct."

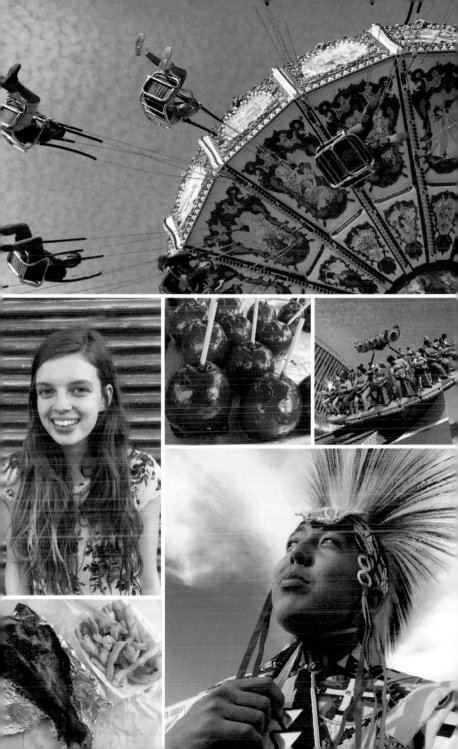

NOT ALL WHO WANDER ARE LOST

This may come as a bit of a surprise to you, but the key photographic difference between zero and hero is intention. Casual intention will generate casual photographs. Purposeful intentions will generate purposeful photographs. I will go to my grave echoing this mantra.

Does being deliberate take the joy and spontaneity out of shooting? I've been at it for forty years, and it hasn't yet!

I know not everyone will agree with me here, and that's more than okay, but for those of you reading this who want more out of your photography, I can tell you with certainty that the road to artful images goes smack through intention.

Use manual mode AND THOUGHTFULLY CHOOSE EACH EXPOSURE.

BE SURE TO HAVE A **clean lens and plenty of power and storage** TO WORK WITH.

As you can imagine, in the editing of this book, I went through tens of thousands of photographs to find just the right ones to share on these pages. Almost, without exception, the ones that are offered here were made with intention.

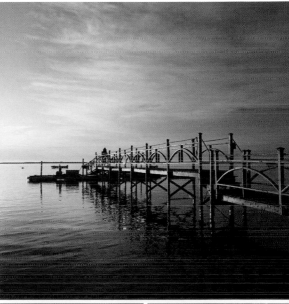

**TRY TO TAKE
EVERYTHING THAT CAN
INFLUENCE YOUR IMAGE
INTO ACCOUNT:
light, exposure,
design, subject.**

**Shooting with intent is active.
IT'S THE DIFFERENCE BETWEEN
WAITING FOR IMAGES TO COME AND
GOING AFTER THEM.**

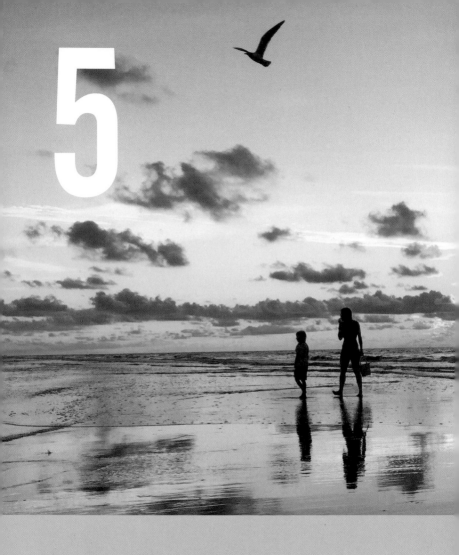

5

BIG WORLD
SMALL CAMERA

I don't remember the date of my first iPhone purchase. What I clearly remember is February 18, 2011, on the Caribbean Island of Barbados. I had a crystal-clear epiphany that morning, watching the sun come up from the beach cliffs: iPhone photography would play a significant role in the rest of my career.

It surely has. That daybreak experience propelled me forward on a trajectory that I am still on today. It's a story of infatuation turned obsession turned mature passion. Since 2011, I have managed to travel to over 20 countries to shoot with my iPhone, racking up approximately 500,000 captures.

The critics seem to tirelessly make their case that an iPhone is only suited for snapshot and social-media photography. The haters will always hate, but iPhone photography is real, and it's here to stay.

Take it from this iPhone lover, an award-winning, career veteran in commercial photography—the iSight camera, in the hands of a smart photographer under good lighting conditions, is one of the most powerful photographic capture devices that you'll ever put in your camera bag, or better yet, in your pocket.

THE ROMANTIC SIDE OF PHOTOGRAPHY

Romantics in photography, just like in poetry and literature, favor a more imaginative, emotional, even lyrical approach to picture taking. Sure, they pay attention to tech, but they're more focused on art.

I have a little bit of both tech and art in my approach. Left brain and right brain work in tandem. If I had to pick between the two, I would likely side more with the feelers than the thinkers. To me, the technical part of photography has always been a means to an end—getting the shot.

The iPhone is ideal for art photography, because there really isn't much tech to be overwhelmed by. Instead of fumbling with buttons, menus, and dials, you can relax, take a deep breath and become the artist you were born to be.

At first, this is as simple as shooting what you're drawn to and temporarily avoiding everything else. Then, once you have modest confidence in your tech skills, you can push on to more challenging objects, concepts, and themes.

Bottom line, don't ever get too far away from your emotions. Keep them close and always make them part of your work. This won't happen overnight, but be patient, keep at it, and wear your heart on your sleeve! Your obsession with emotion in photography won't get you invited to speak at camera clubs. Don't worry about that. The more you feel through your photographs, the more viewers will too.

My advice for those of you wanting to become a better photographer: First, become a better you. What we shoot is a natural extension of who we are. In the process of finding out what makes you tick, you'll have a better chance of finding out what makes you click.

Every photograph you take is a delicate combination of technology, technique, and talent, all working toward a common visual goal. In this chapter, I will share with you what I consider to be some basics of these "Three T's." You will most certainly find your own balance among them as you go.

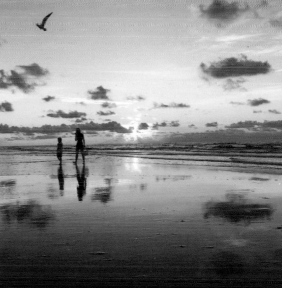

RIOT OF COLOR

While I have always appreciated a good black-and-white photo, I'm so much more seduced by color. Color is the spice of life, and it is a key driver in evoking emotion in your photographs. It is, without question, one of the most powerful forms of non-verbal communication.

Early influences in my own color journey were photography greats like Elliot Porter, Ernst Haas, Lisl Dennis, and Jay Maisel. Aside from chasing light, chasing color has been a very close second for me.

Color is one of those topics you'll rarely get two photographers to agree on. That's because color is subjective and emotional. Do you know what your favorite photographic colors are, and why?

One photographer might like deeply saturated colors, while another prefers a muted color palette. One may lean toward warm colors, and another might boldly choose cooler colors. Some minimize the amount of color they put in a frame and use color (or its absence) for emphasis. Others might load it up.

We are all creatures of color, in our own unique ways.

The Psychology of Color

Red	Yellow	Green	Blue
passion	joy	harmony	trust • melancholy
desire • love	happiness	fertility • safety	wisdom • loyalty
energy • warning	life is good	growth	confidence

Try capturing a single dominant color AND MAKING ALL OTHER COLORS SECONDARY.

Indirect light tends to show off color the best, so LOOK FOR OPEN SHADE.

Purple
royalty
wealth • dignity
creativity

White
goodness
innocence
purity • afterlife

Black
power • mystery
elegance • formality
death • evil

DYNAMIC RANGE

Dynamic range is a way of describing the range of light values in a scene or photograph. It's measured in exposure value (EV), or stops.

Photographically speaking, there are two kinds of dynamic range to understand: that of the scene you're photographing, and that of the camera's imaging sensor. These two are not always the same. The simple goal is to make sure that the dynamic range of the scene does not exceed the sensor's.

Cameras vary in their ability to handle dynamic range. The iPhone, with its smaller 1/3" CMOS sensor, has an approximate 8-stop dynamic range. In contrast, most modern full-frame sensors have a dynamic range of 13–15 stops.

Let's say that, for example, you're shooting an outdoor, brightly lit scene with a 6-stop dynamic range. The iPhone camera will have no problem handling both ends of the exposure spectrum: highlights and shadow. But if this same scene had, say, a 10-stop dynamic range, it would exceed the dynamic range of the sensor, which would result in blocked-up shadows or blown-out highlights, otherwise known as loss of detail.

It so happens that the iPhone's camera sensor is best-matched to evenly-lit, relatively bright, outdoor scenes. Even though the 6–7 stops of an indoor scene is a smaller range than that of the iPhone camera, it falls on the darker end of the spectrum (see illustration below), which isn't the iPhone's area of specialty.

You can be sure that our good friends at Apple are working overtime to deliver to us better technology on future models.

TOP-OF-THE LINE FULL-FRAME CAMERA

HUMAN EYE

iPHONE

INDOOR SCENE

EXPOSURE TRIANGLE

Exposure is the process of letting light through the camera lens to expose the digital sensor. Every single exposure you ever take is equally affected by three controlling factors: aperture, shutter-speed, and ISO. Together, they're known as the exposure triangle.

Aperture. Controls the intensity of light hitting the sensor.

Shutter speed. Controls how long the sensor is exposed to light.

ISO. Overall sensitivity of the sensor to light.

The aperture on the iPhone's five-element, 4.2mm lens is a fixed $f/2.2$. It doesn't change, regardless of lighting conditions. The shutter speed and ISO are "baked" together. You cannot independently control either one.

In my book, there is no such thing as a perfect exposure. What is perfect for some might not be for others. Some photographers like their photos light and bright. Others like them dark and moody.

I prefer the term "optimum" exposure, where there is sufficient detail from the bright highlights to the darkest shadows, and the mid-tones are well-saturated with color.

Learn to get exposure right in camera, and you'll save yourself hours of post-processing work. After all, exposure is the heart of the capture process. Get it right, and you're well on your way to creating a fine body of work.

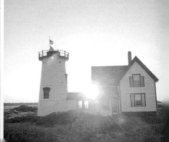

Common Problems	Easy Solution
HIGH-CONTRAST SCENE Lots of shadows and highlights	Expose for highlights and let shadows go dark. Shadow detail is easier to retrieve in post-processing.
BACKLIGHT Bright light behind the subject, causing silhoutte	Set the exposure reticle to the subject. Use the exposure compensation slider as needed.
FLARE Bright spots in photo caused by sun, can reduce contrast	Keep the lens flare for effect, or place your hand above the lens like a shade.
DARK/LIGHT CONFUSION Underexposed dark scenes; overexposed light scenes	Use the exposure slider until the key part of the scene has the exposure you want.

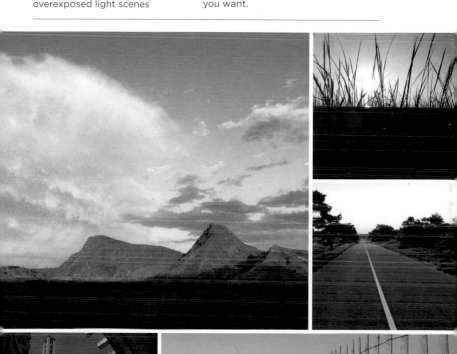

PLANES, TRAINS, & AUTOMOBILES

Understanding shutter speeds is essential for both capturing moving subjects and shooting from moving vehicles. Here are a few fundamentals.

First and foremost, in the current iPhone ecosystem, shutter speed and ISO are baked together. In other words, they're inseparable. If you want to control them independently, check out third-party apps such as Camera+ or Pro Camera 8.

Shutter speed on the iPhone, or any camera for that matter, is the amount of time the shutter stays open to collect the light hitting the sensor (think of it like a curtain or a window). The longer it's open, the more light it lets in.

It's measured in fractions of a second (i.e., 1/30, 1/60, /125, 1/250, etc.). Moving from one setting to the next either doubles or halves the amount of light hitting the sensor. For example, 1/30 is half the amount of light as 1/15, and double the amount of light of 1/60.

Short shutter speeds (1/500 and faster) can be used to freeze action. Long shutter-speeds (1/15 and slower) can be used creatively to blur your subjects. (See the photos, at right.)

So, how do you actually see the shutter-speed in action on your iPhone? Sadly, you don't or can't, unless you use one of the third-party camera-replacement apps I mentioned earlier.

The good news here for a lot of you is that the iPhone does all the shutter-speed thinking for you quietly under the hood, so you can go about your business of just getting the shot.

Shutter Speed Scale

1/8000	1/4000	1/2000	1/1000	1/500	1/250	1/125	1/60	1/30	1/15
FREEZE ACTION *Hand held, no tripod needed*					Hand held, no tripod needed			MOTION BLUR *Tripod needed*	

less light strikes sensor ⟶ more light strikes sensor

freezes motion ⟶ blurs motion

less noise ⟶ more noise

THE SNAPSHOT AESTHETIC

The Kodak Brownie camera revolutionized amatuer photography in 1900, eventually bringing about the "snapshot aesthetic." Kodak's famous advertising slogan offered, "You push the button; we do the rest." Sounds a lot like iPhone photography, doesn't it?

The snapshot aesthetic is about making good-quality pictures simple and accessible for everyone, not just for trained professionals. It's not about shooting to hang photographs in museums. Rather, it's about spontaneous captures.

The snapshot has been the main function of smartphone cameras since their advent. Snapshot shooters are mostly consumers with no background or interest in photography, just shooting and sharing moments and memories.

On the other side of the hall are the photographers, amateur and professional, who obsess about the art and science of photography. This crowd has historically been quite distinct from the snapshot shooters.

Now, I see the emergence of a new breed of iPhone photographer. This new breed combines the best of both worlds into what I call a "professional snapshot." The content is still snapshot in nature, but more artful and deliberate.

If you look closely enough, you see thousands of such pictures on Instagram, photographed not by professionals, but by enthusiasts who have grown up under the umbrella of photography as the new lingua franca.

I just love this hybridization. It properly celebrates both groups. The snapshot folks get to have their focus on content, but they do so in a more intentional and stylistic way. The photography group keeps their focus on art while relaxing and making room for a more easygoing methodology.

Quick Look at the Photos App

There are a lot of photo editing apps out there, but the native Photos app is quite powerful. Let's take a quick look at what I consider to be its most useful attributes.

STRAIGHTEN HORIZON **CROP**

Straighten Horizons and Crop. No sweat if you took a crooked picture or didn't get as close as you'd like. You can fix it!

Integrated Camera Roll. Why send your photos to another app for editing? They're all right there!

Moments, Collections, Years. This is such an intuitive way to organize your images. It couldn't be any easier to find the shots you've taken. You can even ask Siri to help you find photos.

Live Photos. Bring special moments to life with a short video. Some think of this feature as gimmicky, but I think of it as awesome.

Smart Adjustment. This is my favorite part and has completely replaced a few of the more robust photo editors I used to use. Most of the adjustment controls you're ever going to need are right here: exposure, brightness, contrast, and saturation. And the adjustment sliders are so fun and fast to use.

Photo Filters and Editing and Tools. Apple includes nine basic filters. If that isn't enough, you can download third-party editing tools and access them from the Photos app.

iCloud Photo Library. Every photo and video you ever take can now live in iCloud. You can access your entire library, from any Internet-enabled device. Changes made on one device are kept up to date across all your devices. What could possibly be easier?

Share Sheets. You can use the share sheets to share your photos or videos via iCloud photo sharing or even Airdrop. Or, you can use it to post photos with a single tap to your favorite social media sites.

6

CELEBRATING
BEAUTY IN NATURE

"A LANDSCAPE IMAGE CUTS ACROSS ALL POLITICAL AND NATIONAL BOUNDARIES, IT TRANSCENDS THE CONSTRAINTS OF LANGUAGE AND CULTURE."

Charlie Waite

Scenic and nature photography have always been beloved pastimes for amateurs and pros alike. What a rewarding pursuit, made that much more so by the compactness and simplicity of an iPhone camera. You can have your hike and shoot it too!

Overall, I would give the iPhone camera a big thumbs up for general landscape photography, though it offers both challenges and benefits.

On one hand, it doesn't have the dynamic range that most dedicated cameras do, so it's not able to record full details and tones in nature. Plus, you don't have the luxury of various focal lengths.

On the other hand, the iPhone does a great job of capturing well-lit scenes. And, the built-in wide-angle lens is excellent for most scenic photography.

To me, what is really cool about shooting landscape photography with the iPhone is its front-to-back range of sharp focus. Even though the iPhone lens has a fixed $f/2.2$ aperture (a setting usually associated with shallow focus), because of the relatively small size of the lens compared to the sensor, it behaves practically more like an $f/22$.

It's just wonderful to know that you have, in your pocket and always with you, a camera that can, under the right conditions, capture discriminating nature and landscape photographs.

THE WIDE WORLD OF PANORAMAS

The panorama mode, which is by far the best I have seen, works by capturing a series of images and smartly stitching them together to form a high-resolution wide-capture photograph. It will take some time for you to perfect your technique, but the rewards are remarkable.

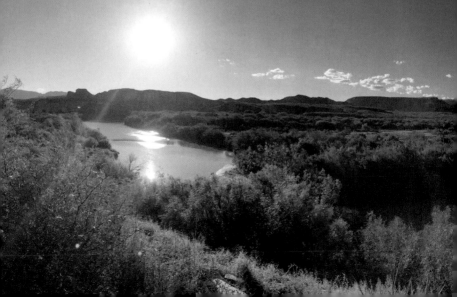

Because of the iPhone, I'm a panorama junkie. I rarely shoot anywhere without trying to knock out a few "panos," as I call them. The process is simple, fun, intuitive, and worth the effort.

In panorama mode, you can capture a 240° image in a single photograph by simply and slowly panning your device. By default, panoramas start from left to right, but you can easily change the direction.

This may seem counterintuitive, but taking panoramas is not supported when the camera is in its horizontal (landscape) position. You create panos by holding the camera vertically (portrait orientation) and following the panning arrow.

As a general rule, panos work better outside in bright, natural light. They are more challenging to create indoors, under contrasting and low-light conditions. Also, when I shoot my own panoramas, I lock my exposure before I begin to pan to avoid any lighting fluctuations caused by exposure adjustments between shots in auto mode.

Trust me, once you start shooting panos, you'll quickly become addicted to capturing them everywhere you go. What an absolute joy to experience the wide world of panoramas!

SUNRISES & SUNSETS

I would be embarrassed to tell you just how many hours over my photographic career that I've spent photographing nature's magnificent sunrises and sunsets: way too many, or better yet, perhaps not enough. Every moment offers a new composition.

It goes without saying that when you're shooting a sunrise or sunset, you need to work quickly because the light changes from moment to moment. Think of photographing in 30-minute blocks of time before and after the sun rises above or sinks below the horizon. Each of these will have its own character.

The Golden Hour happens twice a day. Once 30 minutes after sunrise, and again 30 minutes before sunset. This is when the light is redder, softer, and sweeter than when the sun is high in the sky. It's the ultimate time for photography. The Blue Hour is the period of twilight before sunrise and after sunset, caused by indirect sunlight taking on a predominantly blue hue. This is also a fantastic time for photography.

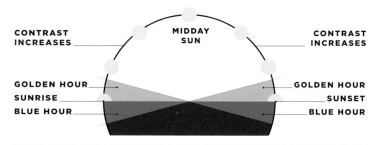

Best times for photographing sunrises and sunsets

PRE SUNRISE Blue Hour	SUNRISE	POST SUNRISE Golden Hour		PRE SUNSET Golden Hour	SUNSET	POST SUNSET Blue Hour
30 minutes	30 minutes	30 minutes		30 minutes	30 minutes	30 minutes

High Noon

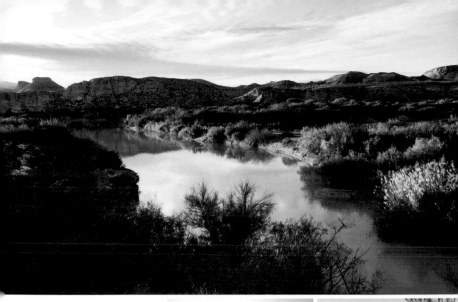

TRY CAPTURING THE **effects of sunrise or sunset,** RATHER THAN THE SUN ITSELF. THE FORMER IS FAR MORE PHOTOGENIC.

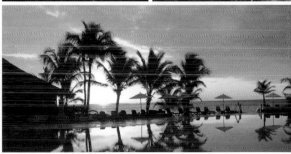

Include a foreground element, NOT JUST TO FRAME THE SHOT AND MAKE IT MORE INTERESTING, BUT ALSO TO GIVE IT SCALE.

NO PLACE LIKE HOME

I adamantly resist the notion that you have to go somewhere to get good pictures. Nonsense. Truth is, great photographs are all around you just waiting to be captured. I would even go as far as saying that the best pictures waiting for you are in your own backyard, neighborhood, or hometown.

I was born and raised on Cape Cod. Even to this very day, with all the globetrotting I've done, Cape Cod is still my favorite place in the world for photography. That's partly because of the special way the light bounces off the sea, sand, and surf. It makes photography special and memorable here.

But there's a deeper, emotional connection to this landscape that supersedes even photography. It's an interconnection with a relationship to my birthplace. I can't prove this out in anyone's experience except my own, but I deeply believe our birthplace can stir within us feelings of comfort, safety, nostalgia, contentment, repose, and serenity. Thusly, our senses are intensified and moved to a heightened state of awareness. I have no other explanation of why, while I'm visiting Cape Cod, the world looks different to me, and my photographs do too.

My point here is quite a simple one: Learn to connect with your surroundings, either your place of birth or place of residence. Begin to explore out of honesty and sincerity your childhood (or recent) memories, fantasies, and dreams. You'll be surprised at the power this yields to your photography.

Photographically, there is no place like home. There is a rich, abundant, and plentiful reservoir of picture delights at every turn. All you need to do is to discover them, then capture them with your iPhone. Stop looking elsewhere. Look in front of you. Look behind you. Look below. Look above. Look around. Really and truly, there is no place like home.

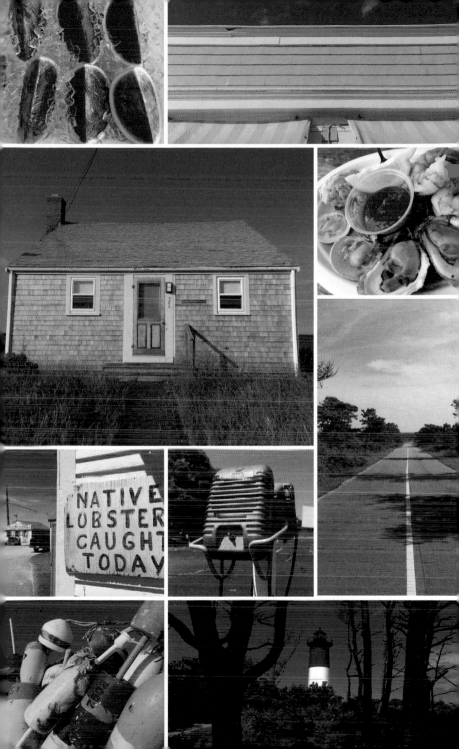

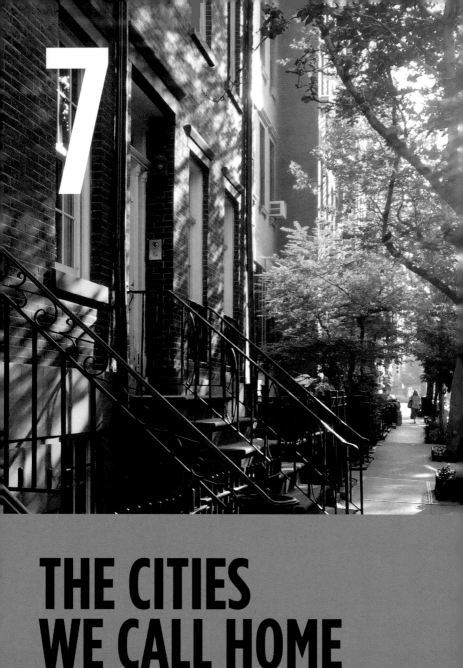

7

THE CITIES
WE CALL HOME

Craig Coverdale

Urban photography is a running documentation and commentary of modern life in metropolitan places. We see, in real-time, all the time, the food people eat, fashion they wear, buildings they inhabit, events they attend, parks they frequent, things they buy, and landmarks they celebrate.

For the first time in history, more than half of the world's population lives in cities. More photography than ever is being done in and around cities. This trend is also thanks in part to the explosion of urban photography on Instagram.

Many landscape photographers seem to clam up when you put them in the heart of a metropolis. Why is this? Maybe it's intimidation or fear? Or not knowing exactly where to point the camera? Maybe the overall scope of a city environment is too big? Regardless of the factors, there seems to be a pretty big gap between nature photographers and urban photographers.

The good news is, if this is you, you can learn to bring the same insights and appreciation you have for pastoral and rural scenes to the urban landscape. Believe it or not, even though the subject matter widely differs, the ultimate craft of chasing light, exposure, focus, design, and color is exactly the same.

IN TALL BUILDINGS

Jay Maisel

Architectural photography, in a traditional sense, includes buildings and structures, from urban skyscrapers to beach shacks to everything between.

We are surrounded by architecture everywhere we go, on a daily basis. So it shouldn't come as any surprise at all that in the mobile space, architectural photography is so crazy-popular.

Photographing buildings and structures, indoors and out, was once the exclusive domain and privilege of trained architectural photographers with view cameras, perspective-control lenses, and hot lights. There is still a need for these professionals, but it's also been quite refreshing to see so many smartphone interpretations of the buildings and structures that make up our urban landscapes.

It really is amazing to me how majestic and resplendent simple buildings and structures look when bathed and painted in just the right light. Glorious indeed. It is my hope that, in my own humble way, I can bring respect, attraction, and admiration to the gentle giants that dot our urban skyline.

Explore!
FIND THE DECAYING
BULIDING, THE COZY
COURTYARD, THE
BRICK ALLEYWAY.

**SHOOT IN THE
early morning
or late afternoon
FOR MORE CAPTIVATING,
DRAMATIC LIGHT.**

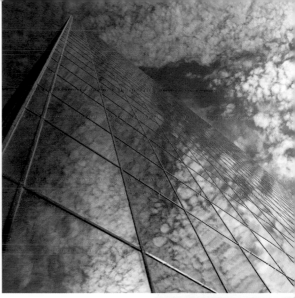

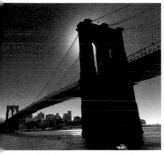

**WHEN PHOTOGRAPHING
A REFLECTIVE SURFACE,
expose for the reflected light
AND LET THE REST OF THE
FRAME GO DARK.**

**Underexpose slightly
WHEN THERE IS A LOT OF BLUE SKY
IN A SHOT, SINCE IT TENDS TO
TRICK THE LIGHT METER.**

APPS FOR URBAN PHOTOGRAPHY

Every one of these apps is a must-own if you shoot a lot of urban settings. Photographing in and around cities presents a specific set of challenges, and these apps can help you overcome those challenges.

SKRWT. This is an awesome app for perspective correction. It's the best one on the market for straightening out building lines that are skewed from shooting with a wide-angle lens.

CORTEX CAMERA. A brilliant app for reducing noise levels in low-light shooting. Exposure times are between 2 and 10 seconds. But you'll be pleasantly surprised to find that it creates sharp, noise-free images and allows you to shoot handheld, too.

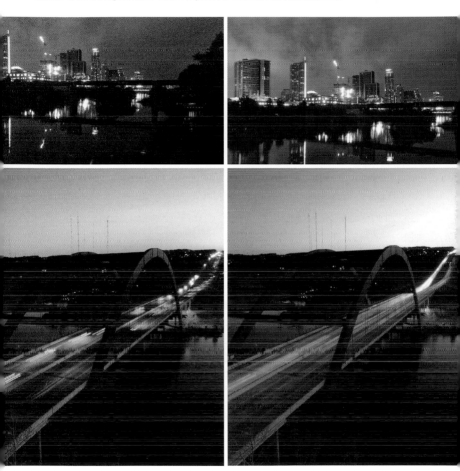

SLOW SHUTTER CAM. This app allows you to independently control shutter speed on the iPhone, which as you may recall, is natively baked with ISO. It's great for capturing trailing traffic lights, and for longer urban exposures.

SHOOTING SKYLINES

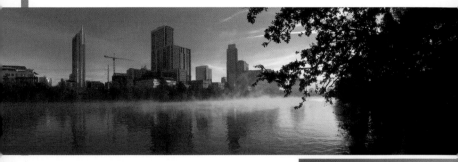

**TO PREVENT CAMERA SHAKE
IN LOW LIGHT,
plug in your Apple EarPods
AND USE THEIR VOLUME ROCKER
TO TRIGGER THE SHUTTER.**

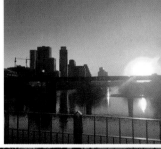

**DON'T PACK UP
AFTER THE SUN SETS.
Wait another
30–45 minutes
FOR THAT SWEET
BLUE HOUR.**

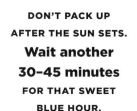

**Use a
wide-angle lens
attachment**
TO CAPTURE
AN EVEN WIDER
ANGLE OF VIEW.

Bring along a mini tripod
TO STABILIZE THE IPHONE
FOR LONG EXPOSURES.

THE WORLD OF HIPSTAMATIC

I have always been bullish about Hipstamatic. It's a great app, with an even greater community of zealot users. I began my own iPhone photography career using Hipstamatic, so I'll always have a soft spot for it.

For you mobile photography history buffs, it was Hipstamatic, launched in December 2009 (before Instagram), that first gave iPhone photography a name, a community, and a home.

If you've never used Hipstamatic, close this chapter right now, install the app, and see for yourself what fun it is. Of all the thousands of apps in the App Store, Hipstamatic continues to be one of the most entertaining for vintage, retro, and just inspiring photography. It's all based on various analog film, lens, and flash combinations.

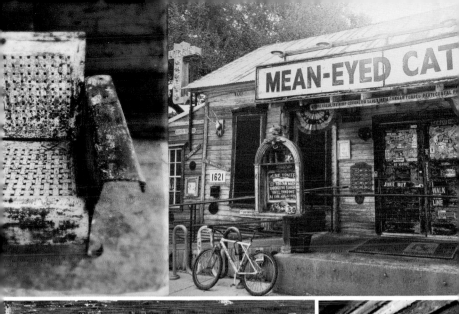

MEAN-EYED CAT

1621

I WALK THE LINE

I WALK THE LINE

AUSTIN TEXAS

THIS SIDE OF HEAV

TAKING TO THE STREETS

I won't go too in-depth about what street photography is and isn't. I think of it as a subset of urban photography, more narrowly defined as shooting candids of people in public places.

Street photography attempts to mirror images of society without alteration At its heart has always been a compact and inconspicuous camera, shooting without subjects' acknowledgment or permission. After all, as many street photographers would ask: Why spoil or interrupt the moment? Just capture it the way it is and move on.

Because most street photographers prefer to work anonymously, the iPhone is undeniably the ultimate camera for it. Since smartphones are so ubiquitous, not many will even notice or pay much attention to you. This creates the perfect opportunity to capture street life as it is without disrupting it.

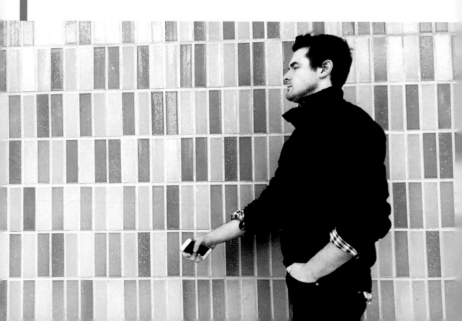

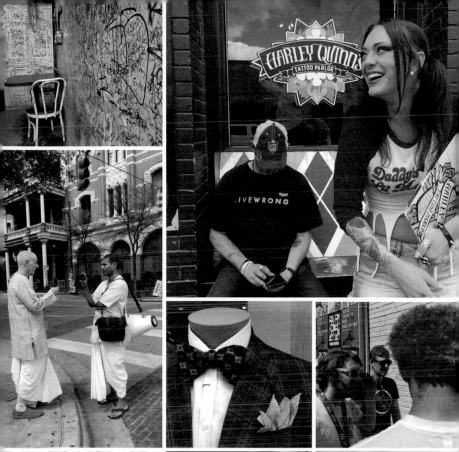

see

He smiles, but she doesnt see

BEYOND THE POSTCARD

A new perspective can be such powerful creative fuel. If you have the opportunity to travel and photograph world landmarks, I highly reommend it.

Here's the deal about photographing a world landmark: There are probably a million and one postcard photos of the place. You have to take real effort to make sure your photography is unique. Find what speaks to you and really explore it photographically.

Of the 7–8 million visitors a year to the great Taj Mahal, I would bet that the vast majority of them only have cliché photographs from the frontal marble platforms of the wading pools. That's too bad because the great shots of the Taj Mahal are from the back and the wings.

Yes, for sure, it's important to get that postcard shot from the front. By all means, do it. At least you have a record of your experience. That said, make this a starting point of your photographic journey, not the ending point.

FOR UNIQUE PHOTOS,
take the road less
traveled.
SPOT A CROWD?
Go the opposite
direction.

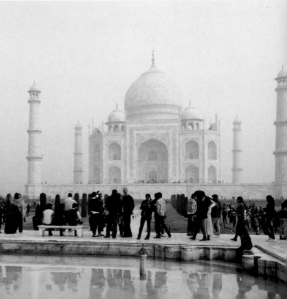

Many world landmark locations do not allow tripods, selfie sticks, or flash photography. Leave these items behind and get creative! Try an app like Cortex Camera to help with low-light hand-held shooting, lean against things or brace your elbows where possible, and try using your EarPods to trigger the shutter, to prevent camera shake.

Arrive early and stay late
TO CAPTURE THE CHANGING MOOD, LIGHT, AND CROWD THROUGHOUT THE DAY.

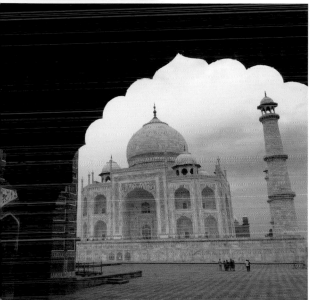

Shoot through doorways, windows, and arches
FOR BEAUTIFUL, DRAMATICALLY FRAMED PHOTOS.

URBAN STILL LIFE

Still-life photographs are ones that feature mostly inanimate and commonplace objects. This style of photography has a long history, and not all of it is tasteful. These days, however, in the social-media space, it's a modern, mature, and compelling art form, often telling a story or depicting a lifestyle.

The omnipossibility of still life puts a unique demand on the photographer; it gives us more creative license to arrange and order elements, and...more decisions to make.

I have been shooting urban still lifes for the better part of my career. These shots are sometimes found—I find and capture the scene without alteration. Other times, they are staged— I intentionally position objects in the frame to satisfy some creative instinct.

Either way, the experience is highly rewarding and fulfilling. These pieces of urbanity will predictably go unnoticed to most. But they won't to you. And that's exactly the point. It's all about discovery—finding curiosity and beauty in the commonplace.

Your skylines, city center shots, and street portraits will probably get you more praise and recognition. But trust me on this: It's these urban still lifes artfully captured that will artistically reward you the most. Don't pass them up.

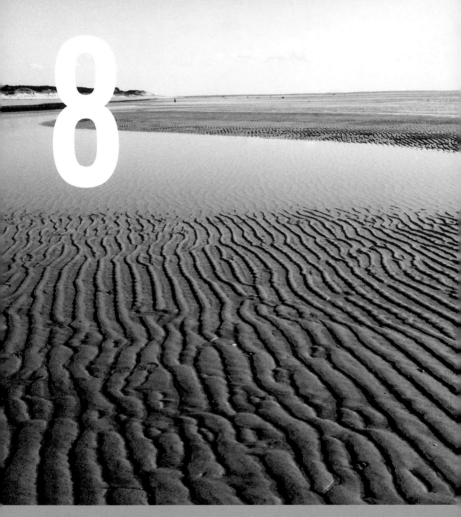

8

LIFE IS COMPLICATED,
MOBILE
PHOTOGRAPHY SHOULDN'T BE

"THE SOUL OF THE ARTIST WILL ALWAYS OUTSHINE THE RECORDING CAPABILITIES OF THE CAMERA."

Robert Wade

When I started shooting iPhone photography back in 2011, I enthusiastically but naively assumed that the road to mobile photographic mastery would mean learning hundreds of apps, owning and using all the best accessories, and only shooting in full-manual mode. Wrong. Wrong. Wrong. That's how I started out, but not where I ended up.

Now I believe, having come full circle, that maximum joy in photography comes from minimal bling and hoopla. Life is complicated. Mobile photography shouldn't be.

You don't need to build hundreds of apps into your mobile workflow. You don't need every accessory. And with a few workarounds, you can shoot the majority of your photos in full auto mode.

"Hey, wait a minute," you say. "What about all that advice you were dishing out to discriminating and discerning mobile photographers to help them raise their games?" That advice is still golden, if you're that type of photographer. Whatever you do, just get out there and shoot.

In this chapter, I've included some basics of improving, enhancing, and celebrating your photos. There is something truly liberating about elevating your art interest. Remember, this is about minimal tech and maximum joy!

WHAT MAKES A GREAT PHOTOGRAPH?

Who really knows? This is "thin ice" territory. From the very beginning of photography, there has been heated debate over this question. Lets agree, for the purpose of this elemental discussion, to keep our focus on fundamental criteria.

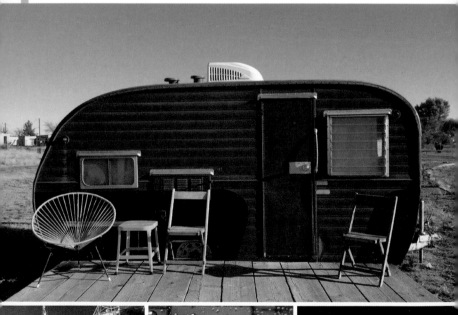

I've been asked over the years to judge photo contests and consult with photographers on their portfolios. The number one criterion, as I have always seen it, is not the technology or technique used to create the photograph; it's what is in the photograph, at quick glance, that moves me. Does it stir my emotional sensibilities and sensitivities? If a photograph gets past this first qualification, then I subject it to a whole series of additional questions.

Is there a clear center of focus and focal point?

Is there optimum detail in highlights, mid-tones, and shadows?

Is the white balance natural or neutral?

Do the photo tell a story?

Does the lighting and color complement the main message?

Is this a strong proof-of-concept of the photographer's vision?

Is the image well-composed by standard elements of design?

Would I hang this photo in my house?

What separates good photos from great photos is part planning, part luck, part technique, part hardware, part software, part nature, part nurture, part serendipity, and part intention. It's literally hundreds of details, natural and technical, all coming together at the same time in a single photograph.

My mantra is this: Success in photography has less to do with the stars in the skies (fate, providence, destiny) and more to do with the stars in your eyes (passion, choice, discipline).

KEEPERS & CLUNKERS

We really don't need any more photos than we already have. We need better photos. Curation, not creation, is the next major frontier in online sharing.

I would like to see us bring back the art of old-fashioned editing. And by editing, I mean choosing between keepers and clunkers. In this Instagram economy, we have somehow managed to eliminate this step altogether and go right from capture to sharing.

Slow down. Shoot more than you share. Share only your very best stuff. Think more like a brand builder creating a cohesive body of work. Be less casual, more intentional.

Smartphone photography, by its very nature, is ephemeral. In a somewhat ironic way, our smartphone pictures are becoming just as fleeting as the very moments and memories we are desperately trying to capture.

Interestingly, as you become more judicious in choosing and sharing, you'll find a rejuvenating energy in the capture process. That's because you'll have so much more time to shoot.

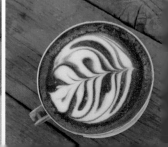

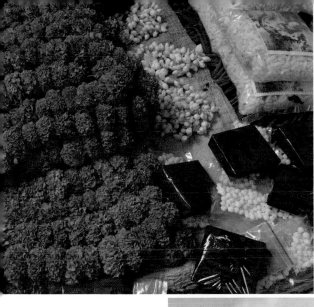

Find a genre and style and stick to it.

Add short captions, tags, and mentions TO GIVE YOUR PHOTO A WIDER REACH.

Watermarking protects your photos, BUT IT ALSO DISRUPTS THE VIEWING EXPERIENCE. THE CHOICE IS YOURS!

A LITTLE HELP
FROM MY FRIENDS

Sometimes digital image files that come out of a camera, even JPEGS from an iPhone, can be a bit blah and bland. Most photos can be greatly improved with just a few common adjustments. Here are the adjustments that I regularly make to my own mobile photography.

There is no right or wrong to any of this. The adjustments you make to your photographs are subjective and personal. And all the adjustments are intertwined; changing one adjustment can affect another adjustment. On pages 128–129, I'm going to give you a list of photo editing aps to explore, all of which will enable you to make any of these adjustments to your photography.

Brightness.
Most traditional brightness sliders brighten the entire image from the shadows to the highlights equally.

BRIGHTNESS BEFORE **BRIGHTNESS** AFTER

CONTRAST BEFORE **CONTRAST** AFTER

Contrast
This is the separation between the darkest and brightest areas of the image. As a general rule, adding a bit of contrast tends to make the image "pop" and feel more dramatic. Don't add too much. Just a tweak!

SATURATION BEFORE **SATURATION** AFTER

Saturation
A saturation slider will provide a nice color boost. Go too far, and the photograph will look garish and cartoonish. Don't go far enough, and it will appear muted.

LIGHT BEFORE **LIGHT** AFTER

Light
Find this in the Photos app. It isn't technically an adjustment control like it is on the other editing apps, but it's my favorite one-touch slider. It's a brilliant smart slider that includes exposure, highlights, shadow, brightness, contrast, and black point. If you're looking for a simple, intuitive fix, this is it!

SHARPNESS BEFORE **SHARPNESS** AFTER

Sharpness
Sharpness in image editing is nothing more than edge contrast. Most images can be improved with a modest amount of sharpening. Don't get carried away, or the result will look unrealistic.

MY PHOTO-EDITING TOOLKIT

It would be fair to call me an app minimalist. Even though I own a lot of apps, I only use a handful with regularity. I prefer to use few and know them well. My simple, photographic style also means that apps are more for refining than defining my work. Here is my short list of best-loved photo-editing apps.

Photos
I use the Apple default app when I want to be in and out of my edit in literally seconds.

Snapseed
Full, multi-dimensional editing experience.

Camera+
Quick tweak of adjustments: contrast, brightness, saturation, sharpness.

PicTapGo
Discerning color palette for my mobile portrait work.

VSCO Cam
Produces elegant, modern film-simulation looks.

Hipstamatic
Quick vintage and retro shots for social media.

Over
Stylized, modern, nicely laid-out typography over photos.

Filters for iPhone
800+ options (there are some cool ones).

Enlight
Pop-art-like Urban filter set.

Mextures
Textural and grunge elements.

Prime and Litely
Additional filters and preset options for classic looks.

PHOTOS **OVER**

SNAPSEED **FILTERS FOR IPHONE**

CAMERA+ **ENLIGHT+**

PIC TAP GO **MEXTURES**

VSCO CAM **PRIME**

HIPSTAMATIC **LITELY**

INSTAGRAM UNFILTERED

Instagram is mind-numbingly popular. In just five short years, it has grown to over 400 million monthly active users who post 80 million photos per day and hit the "like" button 3.5 billion times. Instagram has popularized photography like nothing else ever in history, making it both universal and fashionable.

If you're a photographer today, pro or amateur, and are not participating in Instagram, then you're missing out. It's the place to be for anyone who loves photography.

While Instagram has never been a photography platform per se, it runs on the currency of photographs and video. It has revitalized my professional life. I'm neither the most prolific or consistent in my posts, but it's a go-to resource for photographic inspiration. And, in that respect, it has never disappointed.

Yes, there is plenty of sub-par photography on Instagram. But, any social platform that gets so many people shooting, beautifying, and sharing their lives in photographs is, in my opinion, a great thing!

Instagram has leveled the playing field for everyone. It has truly democratized the product and process of photography in pop culture. It has prepared a global audience, hungry for this new visual language, to receive our photographic contributions with openness and eagerness. Thank you, Instagram!

Don't sell anything.
BE YOUR AUTHENTIC SELF.

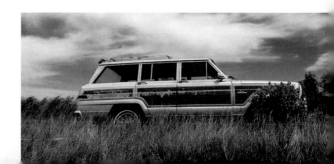

Stick to a single genre or style
TO DISTINGUISH YOUR PHOTOS.

FOR EVERY ONE
IMAGE YOU TAG,
**comment on
two and like
three.**

DEVELOPING A STYLE

"BE YOURSELF; EVERYONE ELSE IS ALREADY TAKEN."

Oscar Wilde

I used to spend countless hours when I was first starting out, fretting over developing a personal style in photography. I read books, went to workshops, and asked the advice of family, friends, and colleagues. Along the way, I even hired a photography consultant or two to help me wrestle with this question. But the more time and energy I devoted, the more distant and far-flung the answers seemed to get.

Then one day, out of the blue, my answer finally came. It hit me like a ton of bricks. Developing a personal style in photography was absolutely nothing more than putting the *me* in my photographs. This was my voice, my vision, my perspective, my photographic take on things, and my point-of-view: my *me*.

The more of that I had in my photographs, the stronger and more recognizable my style became. To create a consistent body of work, you're going to need to create a consistent style. That means putting all that you are, by nature and nurture, into all that you photograph.

Don't get me wrong, almost all artists start out imitating or emulating someone. As you shoot more and more, you will graduate from imitation to adaptation, to all-out invention.

Your personal style may also change many times over your photography journey. That's natural. Style grows out of vision; and our vision, which is our photographic core, changes with our life experiences.

Just so I'm clear, subject genre is not the same as style. Subject genre is what you shoot. Style is how you shoot it. In fact, you may have different styles for different genres of photography. Just keep shooting, and be yourself. Your style will come!

DON'T STOP HERE

I love what the iPhone has done for photography. It has democratized the product and process of photography for anyone, anytime, anywhere. It has created a visual scrapbook of life on planet earth like never before. It has brought fun, joy, spontaneity, and exuberance back into the art of photography. It has awakened the artist within millions of us worldwide.

Despite this revolution, there will always be a lot of just-okay photographs out there, because many photographers will never take the time to understand light, exposure, composition, etc. Great photography is about intuition, but it starts with a knowledge of the basics.

Learn the basics—and you will be heads above the rest. Your photography will stand out. And as you get in touch with your art, find your style, establish your brand, and put your "you" into your photographs, real beauty will emerge, consistently.

We are living in one of the most epic and glorious periods of history to be taking pictures. Photography has never been so fun, accessible, creative, and powerful as it is today, thanks in large part to the smartphones we carry around in our pockets.

Don't stop here. Keep going. Shoot your heart out. Learn what it means to be a photographer in the truest sense.

With virtually no educational training or capital investment, you have the chance of a lifetime to create and publish photographs that, only a few years back, were unthinkable. This is your time. Give us reason to follow you. Enlighten us as to what life is like through your lens. And do it, as only you can, with unfailing and inexhaustible vision.

RESOURCES

PRINTING SERVICES

Artifact Uprising. A printing company that makes custom photo books, albums, prints, and cards.

Get Recently. This service will send you your Camera Roll in a monthly printed magazine. Trust me, your first issue will hook you for life!

Chat Books. A very easy way to turn your digital photos into photo books. No more burden of having to create an ongoing family scrapbook. You can now have a 6 x 6-inch book, one photo per page, archival quality paper and ink, pulled directly from your Camera Roll.

Simply Color Lab. Gorgeous prints on natural wood with a nice, naturally modern aesthetic. If you have been looking for a unique way to print and hang some of your hero iPhone photos around the house, this would be it.

Social Print Studio Photostrips. Old-style photo booth prints. You get a set of nine strips with four images each, printed on thick luster paper. Or, you can get giant photo strips with eight photos. Surround yourself with the memories you most treasure.

iPanorama Prints. Here's a vendor that is specifically set up to print your priceless panoramas. Their print sizes range from 18 to 72 inches wide, printed on thick, glossy photo paper. They offer framed prints too.

Parabo Press. Printing for design-minded photo takers. All of their products are pretty darn cool, but my three favorites are the According Zine, Newsprints, and Risograph Prints.

PRODUCTS

COVR Photo is a lens attachment that allows you to capture natural, candid scenes without spoiling the moment, by inconspicuously holding your phone perpendicular to your body. Great for parents and street photographers.

Ollo Clip macro. A close-up lens attachment. It comes in three different magnifications: macro 7x, macro 14x, and macro 21x.

Field Notes Brand. There are certain things I'm totally old-school about. One of them is taking notes, while on location, with paper and pen. When my ideas are on paper, written in my own hand, they feel more permanent and real to me. These booklets also look really cool and are small enough to tuck away in my pocket or camera bag.

Moment Lenses. iPhones, unlike big cameras, are limited to only a handful of quality accessory lens manufacturers. One of these lens manufacturers that I have grown to respect and love is Moment. I would even go as far as saying that I believe their products are the best for discerning mobile photographers. These lenses are made with construction quality, nearly zero distortion and minimal chromatic aberration. They aren't cheap, but you get what you pay for.

Rostrum Camera Stand. This cleverly mounts to the wall, allowing you to capture any number of small moments from an overhead angle. When you need to shoot on location, the flat-pack, compact, and fully portable Rostrum Camera Stand is instantly good to go.

Cooph Store. You'll hardly need one of those old-fashioned safari vests for your journeys as an iPhone photographer, but this online store offers all sorts of cool clothing for photography enthusiasts.

PhotoJojo. So many fun and clever gadgets and gifts for yourself or fellow iPhone photo lovers.

PUBLICATIONS AND EDUCATION

Bigger Picture Card Set. 10 knowledge cards and 40 task cards including exercises from various fields of photography. They are specifically designed to get you shooting in new and exciting ways.

Learn Photo365 iPhotography Assignment Generator. This app is aimed at helping photographers make better pictures, not about doing things to photographs once they're shot. It includes thousands of great shooting ideas.

EyeEm Magazine. EyeEm is a community and app for the new photographer. They also have a stock marketplace and a magazine. If you dig photography magazines, you're really going to enjoy this 100+ page glossy one that features some of the best and brightest photographers in the growing EyeEm community.

Shooter Magazine. A magazine of photographs by mobile photographers, designed to give an artistic voice to the snapshot.

iPhone Obsessed. If you really want to geek out on apps, tech, and techniques, this is the place to do it.

iPhone Photography School. Excellent tutorials to help you graduate from snapshot to intentional photographic art.

Snap Snap Snap. Blog and vlog tutorials also available as downloadable pdfs, including a number of posts from yours truly!

ONLINE

Mobile Photography Awards. Periodic themed exhibitions and a big annual competition to recognize mobile photography artists around the world with cash prizes for winners!

iPhone Photography Awards. An annual worldwide competition that has been around as long as the iPhone; open to iPhone, iPad, and iPod Touch shooters.

Crated. Sell, discover, and buy art. List prints of your mobile photos for sale through your own online gallery...for free. You decide how much to charge for your work, and you keep 80% of the profit. When someone orders a print of your photo, Crated creates the print and sends it to them.

Life In LoFi. A hard-working blog site about all things iPhoneography: gear, apps, latest features, product reviews, social media, and more.

The App Whisperer. Boasting a simple and slightly old-school interface reminiscent of DPReview, The App Whisperer is the self-proclaimed world's most popular mobile photography and art website. Find news, geek stuff, apps, book reviews, how-to, everything!

iPhoneography Central. Another excellent iPhoneography blog site, but with more emphasis on art.

Skipology. Paul Brown's beautiful mobile photography website offers tutorials organized by genre as well as app resources and lots of sample images, but if nothing else, follow it for inspiration. His photography is expressive and moving.

Pixels at an Exhibition. An online, curated iPhoneography gallery exhibition.

Tag it #JJ. An Instagram photography community that engages users with daily themes, events, and competitions. The motto is, "Create to connect."

APPS AND EXTENSIONS

It took me a while to realize it, but I believe the default native Camera app is the best one for general photography. There's something in it for everybody. I wish someone had told me when I was first starting out to learn the default app inside and out, before I started messing with other apps.

Photographic insiders suggest that there are easily over 30,000 photo-related apps in the App Store. It is my personal opinion that less than 200 of them have ongoing value to discriminating mobile photographers. I have included here my own complete list of useful apps. You will find your own favorites too, but I hope this list will give you a solid foundation.

Note: One very important thing to be aware of when it comes to photo apps is that there are quite a few in the App Store that do not support high-res output. Look carefully in an app's settings to find out. This may not be an issue if you only ever post your images on social media, but if you want high quality, steer clear!

iPhone Native
Camera App
Photos App

Camera Replacement
Camera+
ProCamera

Manual Control
Pureshot
Manual
645 Pro mark III

Sharing
EyeEm
Instagram

Video
Filmic Pro
iMovie
Hyperlapse

Photo Management
Dropbox
Photo Transfer
The Roll

Photo Editing
Snapseed
VSCO
Hipstamatic
Lightroom Mobile
AfterLight
Enlight

Printing
Recently

Speciality
TouchRetouch
AfterFocus
Mobiography
Flipagram
Dramatic Black and White
Layout

HOW-TO

This was always meant to be a book of inspiration, to get you going on your journey as a mobile photographer and guide you toward more artful photographs. I intentionally kept instruction to a bare minimum, but here are the things I couldn't leave out.

Update your iPhone with the latest iOS Software. Plug in your device and connect to the Internet via Wi-Fi. Tap Settings > General > Software Update. Tap download and install. Done!

Trigger the camera shutter five different ways. The traditional method of pressing the button on the screen isn't always convenient. There are a number of other options.

1. The most obvious method: Tap the on-screen shutter button.
2. Use the phone's volume rocker, up or down. This can feel more like you are using a dedicated camera.
3. Use the volume button on your Apple EarPods. This can prevent camera shake, since you don't have to touch the phone to trigger the shutter, and it allows some distance between you and the lens for taking more flattering selfies.
4. Any number of accessory remote Bluetooth shutters release products also do the job. I personally like and use the remote from iStabilizer.
5. Several third-party apps allow you to touch anywhere on the screen to trigger the shutter. Try ProCamera.
6. If you have a tripod, you can use the built-in timer (which will automatically take a full burst series of shots).

Manage white balance (WB). Our smartphone cameras have eyes but not brains. Our brains automatically adjust to all color temperatures from all light sources so everything looks as natural and neutral as possible. Our smartphones cameras do not have the same luxury. Depending upon the light source, colors don't always look right.

The iPhone camera bundles together focus, exposure, and (auto) white balance, but third-party camera apps like Camera+ and ProCamera allow you to independently set all three. I strongly recommend using one of these apps to manage WB on your own.

INDEX

DEDICATION & ACKNOWLEDGMENTS

DEDICATION
I dedicate this book to Shannon, the love of my life. And to my two daughters, Emma and Audrey, the brightest luminaries in my photographic galaxy.

ACKNOWLEDGMENTS
My sincerest thanks are due to the following people for their contributions in helping bring *The Joy of iPhotography* to market: Adam Juniper, Shannon Hollingsworth, Lynn Loomis, Becky Shipkosky, and Ginny Zeal.